CORNWALL
THROUGH TIME
Derek Tait

AMBERLEY

Acknowledgements

Photograph credits: The Derek Tait Picture Collection, Paul Willis, Steve Johnson, Maurice Dart, Bruce E. Hunt, Richard Eastwood, Dave Barclay, Alison Kennaway, Helen Wyler, Jon Spence, Rick Parsons, Jeremy Winterson, Ken Hircock, Robin Jones, Baz Richardson, Graham Pratt, L. J. Alcock, Tim Green, Ian Swithinbank, Karen Freeman, Pavla Hozikova and David Smiles.

Thanks also to Tina Cole and Tilly Barker.

I have tried to track down the copyright owners of all photographs used and apologise to anyone who hasn't been mentioned.

Please check out my website at www.derektait.co.uk.

Bibliography

Books
Saltash Passage
Mount Edgcumbe
Saltash
Saltash Through Time
Rame Peninsula Through Time
River Tamar Through Time
River Tamar Through the Year

Websites
Cyberheritage at:
www.cyber-heritage.co.uk

Derek Tait's Plymouth Local History Blog at:
plymouthlocalhistory.blogspot.com

The Flickr pages of Paul Willis (Worthing Wanderer) at:
www.flickr.com/photos/34911734@No7

Fisgard 1957 website at:
www.tiffs4ever.com

Newspapers
The Evening Herald
The Western Morning News

First published 2012

Amberley Publishing
The Hill, Stroud
Gloucestershire, GL5 4EP

www.amberley-books.com

Copyright © Derek Tait, 2012

The right of Derek Tait to be identified as the Author of this work has been asserted in accordance with the Copyrights, Designs and Patents Act 1988.

ISBN 978 1 4456 0723 8

British Library Cataloguing in Publication Data.
A catalogue record for this book is available from the British Library.

Typeset in 9.5pt on 12pt Celeste.
Typesetting by Amberley Publishing.
Printed in the UK.

Introduction

Cornwall is one of the most beautiful counties in Britain. Stretching from Saltash to Land's End, it features some of the most wonderful scenery in the country. Scattered across its picturesque landscape are many abandoned tin mines and other relics of Cornwall's past.

The county is steeped in history and was first inhabited in the Palaeolithic and Mesolithic periods and continued to be occupied in Neolithic and Bronze Age times. Many relics from this time have been found. Although Roman rule was thought not to have stretched west of Exeter, remnants of Romans living in the area have been discovered including a gold pestle on the Rame Peninsula.

Many of the industries that once thrived in Cornwall including fishing, mining and agriculture have now gone or are diminished and the biggest industry today is tourism.

With the introduction of the railway and the building of the Royal Albert Bridge by Brunel, spanning the River Tamar in the 1800s, Cornwall became more accessible and became a popular destination for day trips and holidays during the Victorian and Edwardian periods. Hotels were built in the 1800s specifically to cater for visitors and many of the buildings still survive although many have seen better days.

Many postcards were sent during the early 1900s and the survival of the images that they carried allows us to see what the area looked like approximately 100 years ago. The Royal Mail allowed publishers to produce picture postcards in 1894 and these featured popular landmarks and scenic views. With cheap and faster travel by train, postcards featuring scenes of the seaside became increasingly popular and thousands still survive turning up in second-hand shops or at auction houses. They provide a true glimpse of the past and without them many scenes featured in this book would have been lost forever.

Horses and carts were eventually replaced with electric trams which in turn were replaced by buses and early cars.

With the introduction of automobiles, charabanc trips became very popular and took people to many destinations that at one time would have been impossible to reach by most. The seaside came alive with visitors. Cafés and tearooms opened up to greet the surge of people; many hadn't seen the sea before.

Much has changed. Some Victorian holiday resorts have become run down and look worse for wear and, today, Cornwall is said to be one of the poorest counties in Britain.

However, it is still a popular holiday destination and is also very well-liked by surfers and other water sport enthusiasts. Regular surfing championship events take place in Newquay and annual sailing events and regattas take place in the many ports around the region, including Falmouth and Fowey.

In recent years, attractions like the Eden Project and the Tate Gallery in St Ives have attracted hundreds of thousands of visitors to the region. Rick Stein's restaurants in Padstow have also seriously revived the area.

There are undoubtedly many holiday homes within the county and many small villages and towns appear dead out of season. Fishing villages full of Cornishmen and their families seem to be a thing of the past.

Cornwall has undoubtedly changed over the years but comparing the photographs, much has remained quite similar.

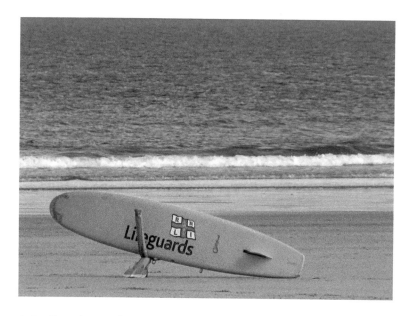

A Surfboard at Hayle Towans Beach

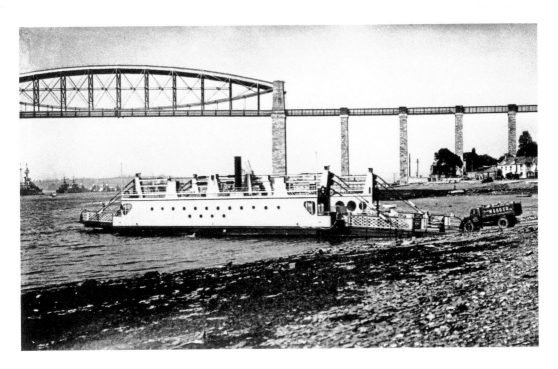

The Gateway to Cornwall

With the introduction of the railway, the Royal Albert Bridge opened up Cornwall to many people. A small ferry had crossed at this point for hundreds of years. The later photograph shows both the rail bridge and the road bridge, the latter opened in 1961. Today, they provide the main route into Cornwall.

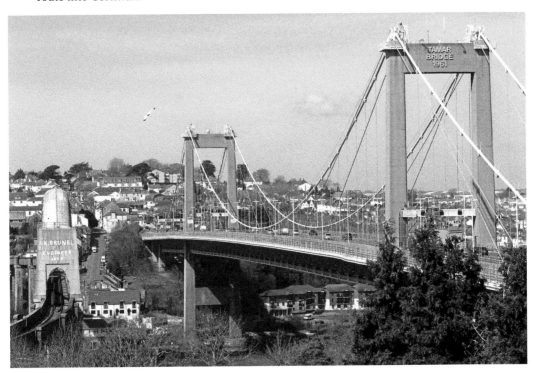

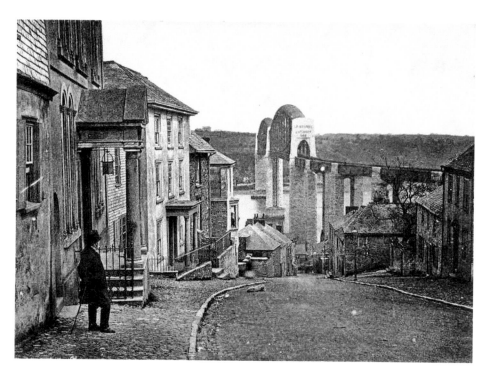

Fore Street, Saltash

The older photograph shows the lower part of Fore Street in Saltash looking towards the Royal Albert Bridge and the River Tamar. Many buildings on the left would later be cleared away when the Tamar road bridge was built. Some of the houses at the bottom of the road survived and can be seen in both photographs.

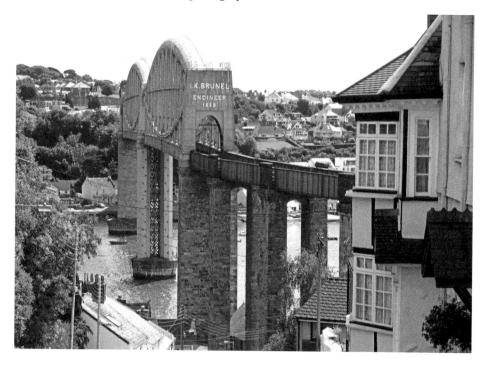

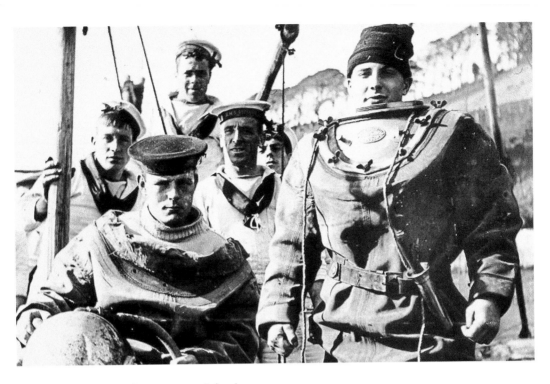

Sailors at Wearde Quay near Saltash

The earlier photograph shows sailors at HMS Defiance Torpedo School at Wearde Quay complete with heavy diving gear. The later photograph shows the area as it is today. The naval base has long since gone and there is little trace of it ever existing.

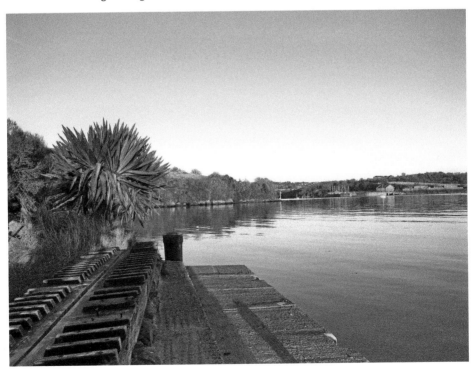

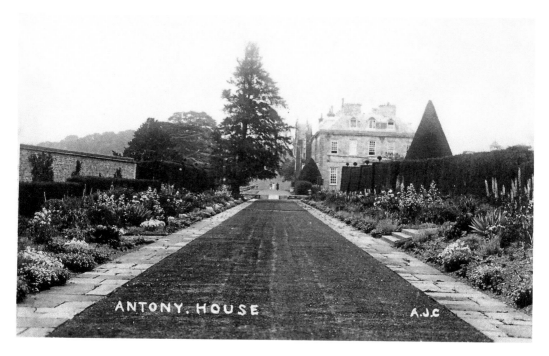

Antony House, Torpoint

The older photograph shows a view of Antony House and the surrounding gardens, little has changed over the last 100 years. *Alice in Wonderland* starring Johnny Depp was filmed at the house in 2008 and characters from the movie can be found around the grounds.

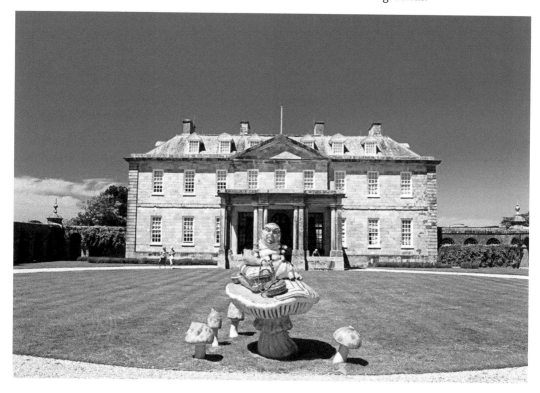

John 'Coggy' Grantham at Jupiter Point
The earlier photograph shows John 'Coggy' Grantham in 1958 at the Royal Navy training establishment at Jupiter Point on the Antony Estate. The training establishment is still there today and the later photograph shows the view looking towards it from Churchtown Farm at Saltash.

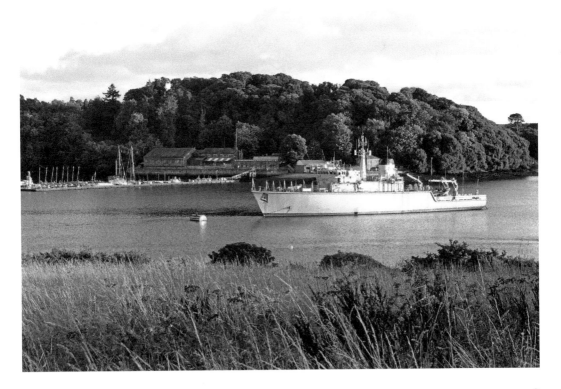

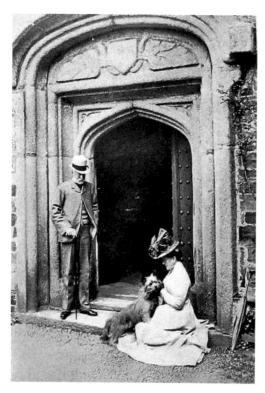

The Earl and Countess of Mount Edgcumbe Visiting Cotehele in 1905
The earlier photographs shows the Earl and Countess of Mount Edgcumbe with their favourite dog, Pepper, at the doorway of their medieval home which came into the family in about 1353. Today, the property belongs to the National Trust and attracts thousands of visitors a year.

Two Girls in Cotehele Woods
The earlier photograph shows two Victorian girls making their way up from the quay at Cotehele towards the main house. The modern photograph shows the chapel on the same woodland path, which was erected by Sir Richard Edgcumbe. It is on this spot that Sir Richard escaped from the king's men in 1483 after joining a rebellion against King Richard III.

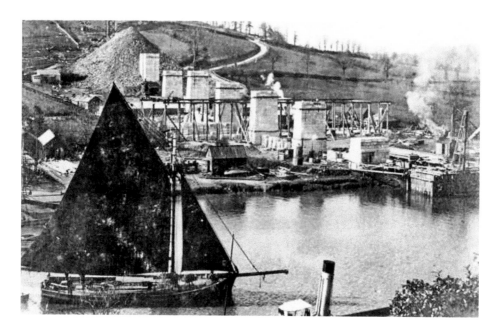

The Building of the Viaduct at Calstock

The older photograph shows the construction of the viaduct at Calstock which was built between 1904 and 1907. A lugger can be seen in the main part of the photograph and a steam ferry can be seen at the bottom of the picture. The later photograph shows the many boats that line the shore today. The reflection of the completed viaduct can be seen in the river.

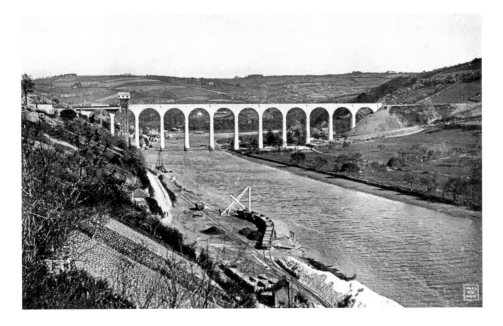

The Completed Viaduct at Calstock

The earlier photograph shows the viaduct soon after completion. The whole construction took 11,146 concrete blocks to complete. These were cast in a yard on the Devon side of the village. Railway loading carts can be seen towards the bottom of the photograph. The newer photograph shows the scene today with just a single boat moored on the river.

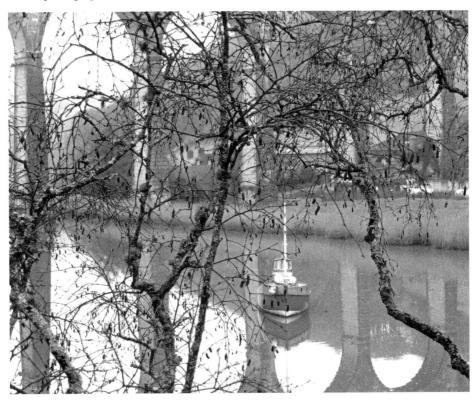

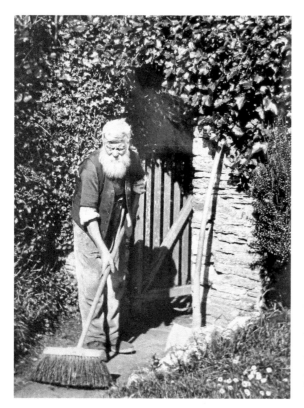

A Sexton Performing his Duties

A sexton can be seen in the older photograph sweeping around the church's grounds. A sexton's job included the maintenance of the church and the surrounding graveyard. The later photograph shows the type of church he would have once looked after. This one is at Landulph on the banks of the Tamar.

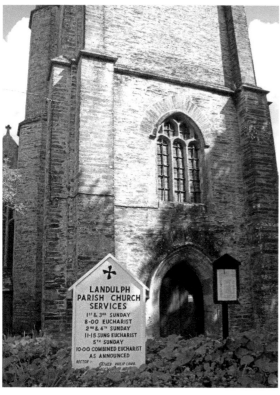

LANDULPH
PARISH CHURCH
SERVICES
1ST & 3RD SUNDAY
8-00 EUCHARIST
2ND & 4TH SUNDAY
11-15 SUNG EUCHARIST
5TH SUNDAY
10-00 COMBINED EUCHARIST
AS ANNOUNCED
RECTOR :- FATHER PHILIP LAMB

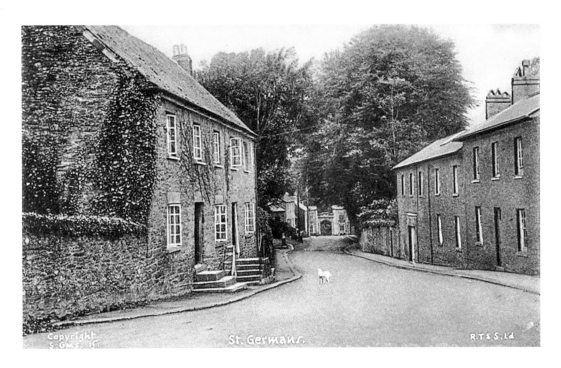

St Germans

The older photograph shows the village of St Germans. A small dog can be seen on the quiet road. Many of the older houses still remain although newer ones have been built in the village in recent years. The later photograph shows the nearby viaduct which spans the River Lynher.

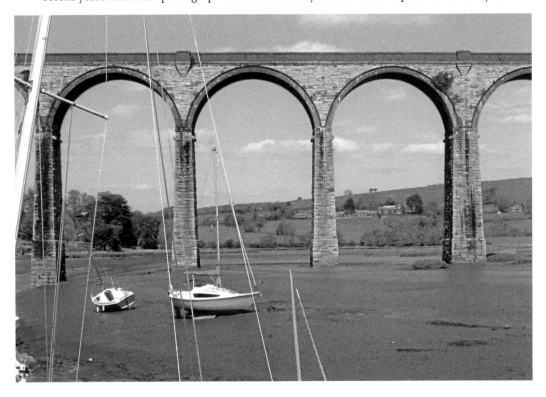

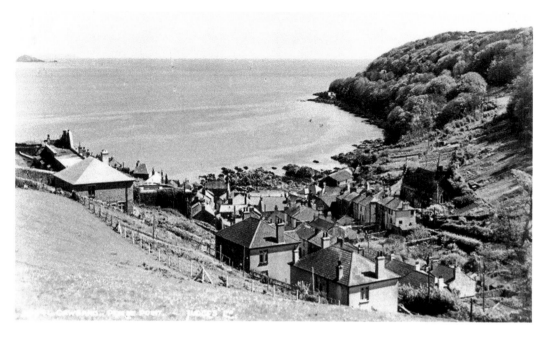

The Village of Cawsand

The older photograph shows the view of Cawsand looking down towards the beach and the heart of the village. Today, many of the homes are now holiday dwellings with some visitors only appearing one week a year. Since the older photograph was taken, more buildings have been built on the left of the picture and also near to the beach.

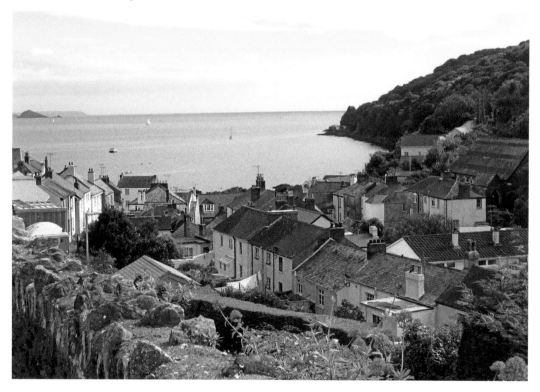

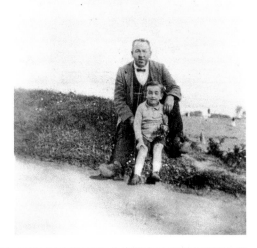

A Man and His Son on the Road to Cawsand
A small boy carrying freshly picked flowers
can be seen in the older photograph together
with his father, who is wearing a bow tie
and waistcoat. The green leading towards
the village can be seen in the background.
The later photograph shows the view from
Cawsand looking towards Kingsand.

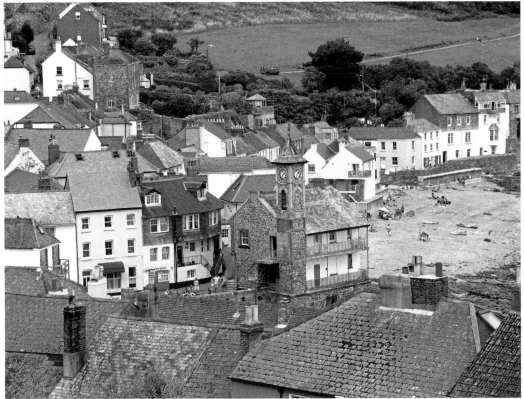

Cremyll on the Mount Edgcumbe Estate

The earlier photograph shows the quay at Cremyll, near to where the ferry from Stonehouse in Plymouth lands. The Italianate Tower House in the background, which was built in the time of Ernest Augustus Edgcumbe (1797–1861), was totally destroyed by enemy bombing in April 1941. Three people lost their lives, including the ferry skipper and engineer.

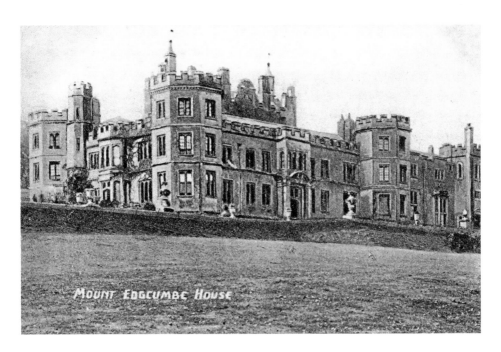

Mount Edgcumbe House

Mount Edgcumbe House was also bombed during the Second World War and was left a shell for many years. Today, the red-bricked house is smaller than it once was and has lost its original stucco finish. It is still an impressive building however and, looking at it today, it's hard to imagine that it was renovated in just 1964. Some sections of the walls are older than 450 years.

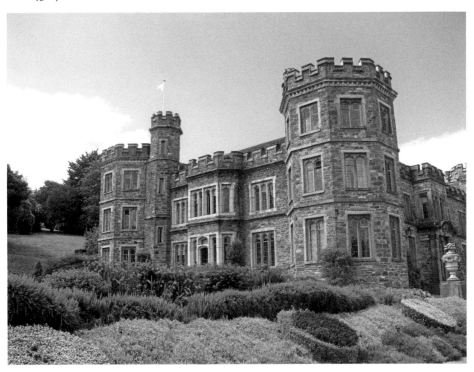

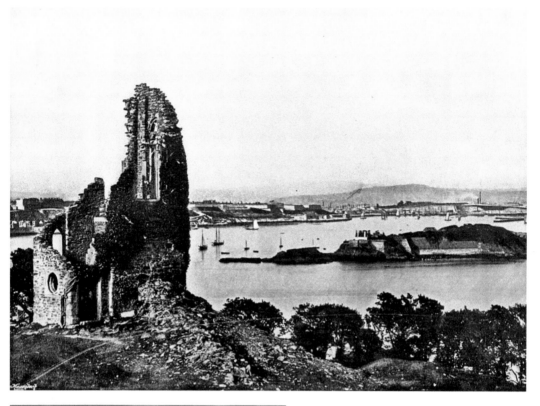

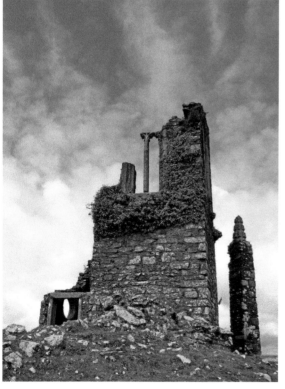

The Folly at Mount Edgcumbe

The Folly was built in 1747 and replaced an obelisk which had stood on the site previously. It was built by using medieval stone from the churches of St George and St Lawrence, which once stood in Stonehouse. The same stone was used to build the Picklecombe Seat further along the coast. Part of the seat features a medieval doorway.

The Path to Penlee Point, Rame

The older photograph shows the wooded path leading towards Penlee Point and Queen Adelaide's Grotto. The grotto was originally just a cave and was used as a watch house in the eighteenth century. It was enhanced with an arched stone frontage and became a grotto after Adelaide's visit in 1827. The later photograph shows the scene from the grotto looking out on the magnificent view.

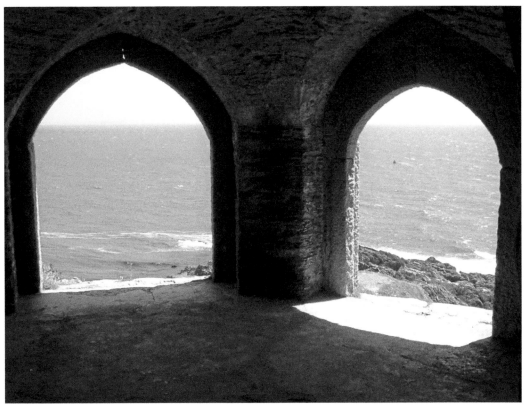

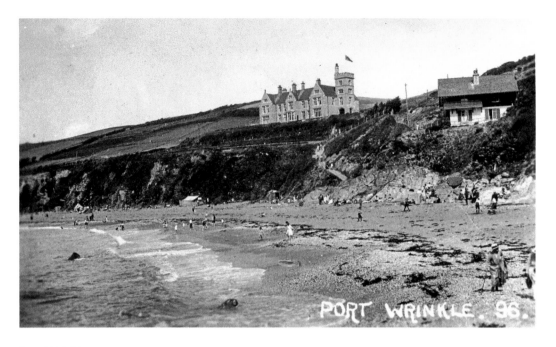

Port Wrinkle

The older photograph shows the beach at Port Wrinkle with many people enjoying the sea and sand. The newer photograph shows the view from the other end of the village. On the left are the old pilchard cellars, which have now been refurbished and are private dwellings.

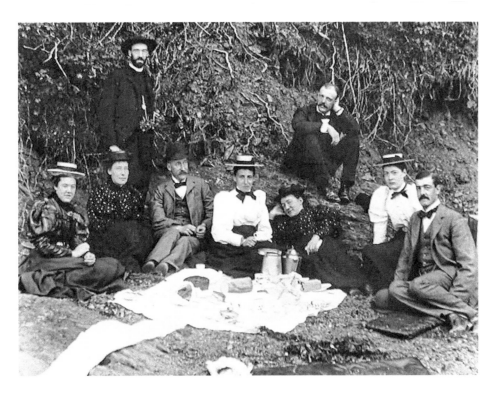

Picnickers at Kingsand

Smartly dressed picnickers enjoy themselves on the beach at the far end of Kingsand. They've come prepared with tea, cake and bread. The later photograph shows a rope swing in the same area of Kingsand beach. In the background are the apartments at Fort Picklecombe.

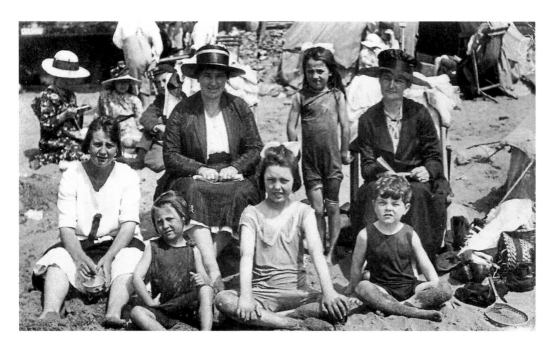

A Family Outing at Downderry

A family enjoy a day out at the seaside at Downderry in the older photograph. They've brought with them buckets and spades, tennis rackets and something to read. They also have their own bell tent which many people used to get changed in or to get out of the heat of the sun for a while. The later photograph shows the beach as it is today.

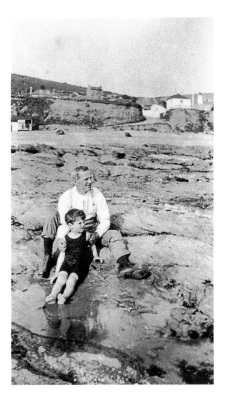

A Father and His Son at Downderry

Since the earlier photograph was taken more houses have been built in the background. The cliff has suffered from erosion and many of the houses have lost vast parts of their gardens. The later photograph shows the view in the opposite direction looking along the sands at Downderry towards Port Wrinkle.

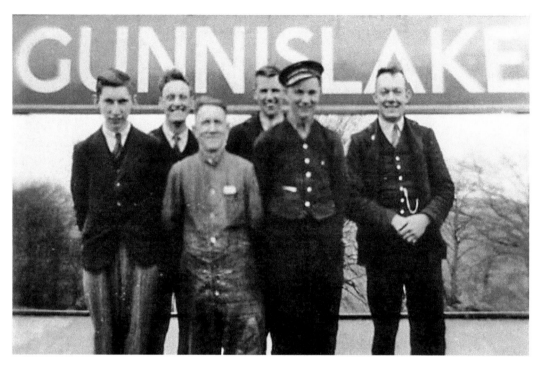

The Staff of the Gunnislake Railway Station
The older photograph shows the smiling faces of the staff at Gunnislake as they pose for the camera. The station was opened in 1872 and passenger trains were introduced in 1908 after the Calstock Viaduct was opened. Today, the station is a much quieter place.

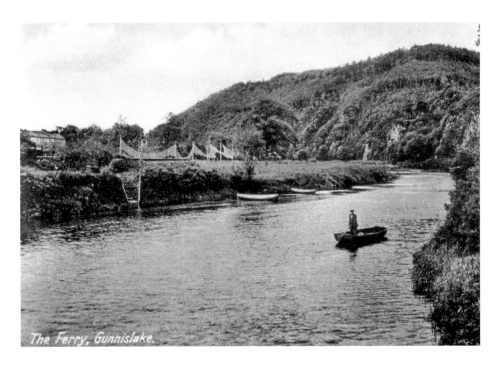

The Ferry, Gunnislake.

The Ferry at Gunnislake

The earlier photograph shows the ferry at Gunnislake, which consisted of one man and a rowing boat. The later photograph shows the nearby New Bridge which crosses the River Tamar and the border between Devon and Cornwall. The bridge was built in 1520 by Sir Piers Edgcumbe.

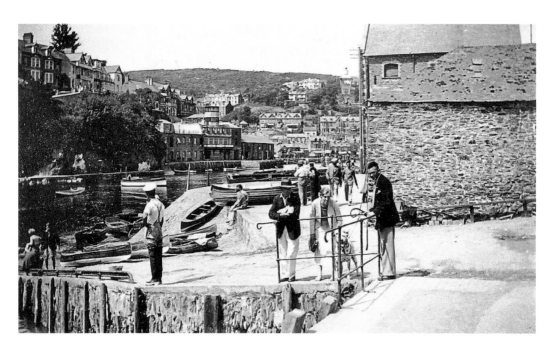

The Harbour at Looe

The earlier photograph was taken in June 1930 and shows Geraldine and Howard Winton. Howard's brother, Geoff, can be seen in the hat and their Dalmatian is also with them. This part of Looe has changed little over the years. The later photograph shows the view looking back towards Looe and the same area.

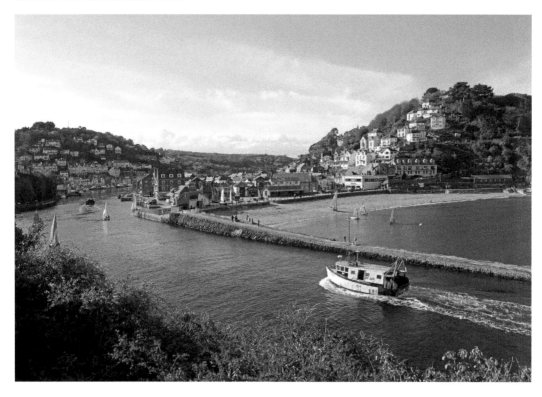

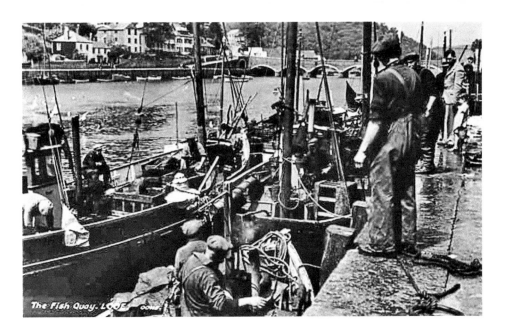

The Fish Quay at Looe

In the older photograph, fishermen can be seen unloading their catch. The later photograph shows the many fishing boats that still land there today. For many years, a seal with one eye would hang around the quay waiting for discarded fish. He was named 'Nelson' by the locals and when he died, Sir Robin Knox-Johnson unveiled a bronze statue of him in the harbour.

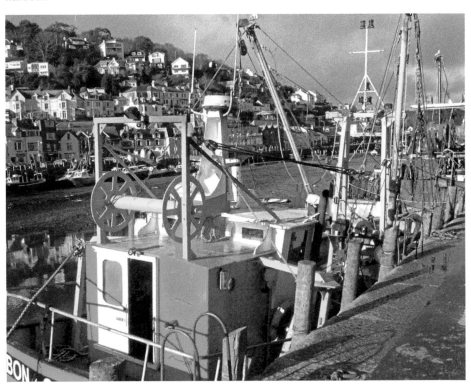

Polperro Harbour

Polperro is a small fishing village dating from the thirteenth century. As well as being the home to fishermen and their families, the village also took part in the lucrative business of smuggling which thrived in the 1700s. The later photograph shows the harbour today, still with many fishing boats.

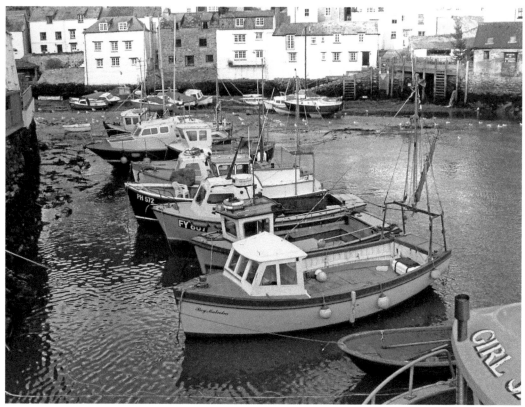

Fishing Boats at Polperro

Many of the houses and buildings in Polperro today remain much the same as they were 200 years ago. Walking through the narrow streets, it's possible to get a feel of how the village once was. Modern restaurants and shops blend in with the older buildings and make the area a popular tourist attraction.

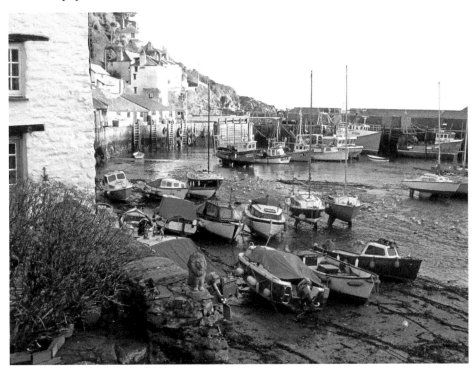

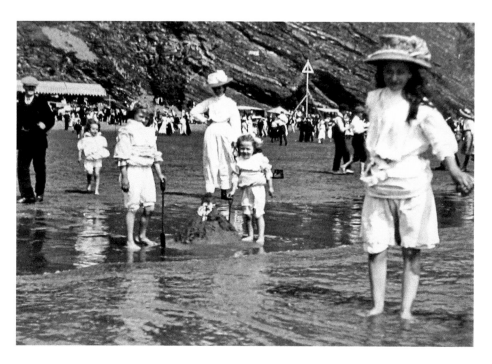

A Victorian Outing at Whitsands

Children and their parents paddle in the sea at Whitsands in the older photograph. The children in the middle of the picture have built a sandcastle. It is funny how beachwear has changed over the years; many of the men are dressed in suits complete with ties and flat caps. The later photograph shows the scene today.

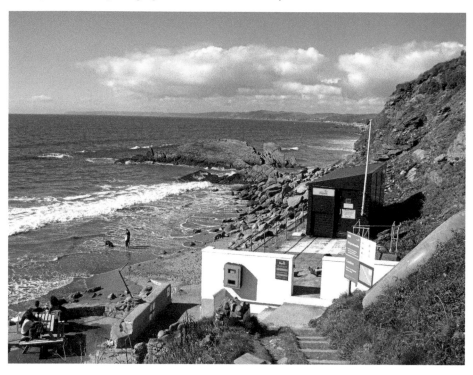

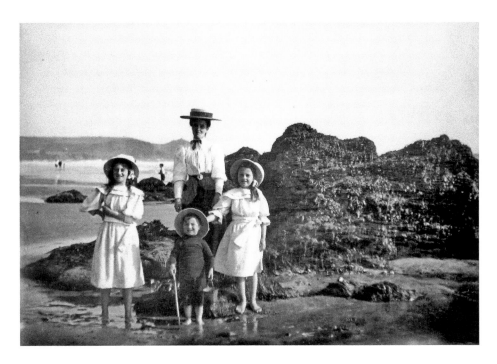

Paddling at Whitsands

A mother and her four children pose for the camera at Whitsands in the earlier photograph. In the far background is the small chapel at Rame Head. The same headland can be seen in the later photograph. A café now stands on the left which is popular with sunbathers, swimmers and surfers.

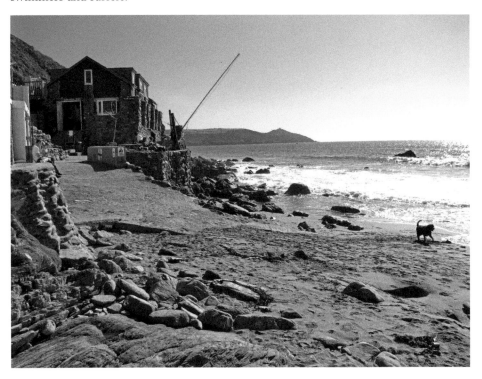

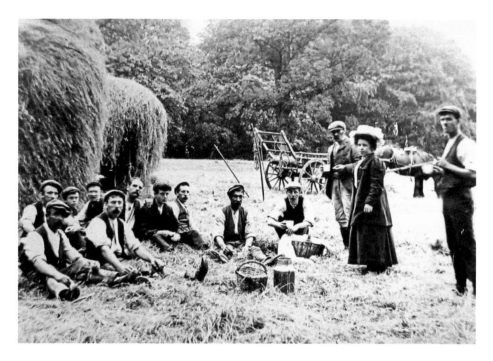

Farming on the Rame Peninsula

A group of farm workers enjoy a break amongst the gathered hay in a field on the Rame Peninsula. Several of the workers look similar and are probably members of the same family. It would have been hard work but today the job is made far easier by modern machinery.

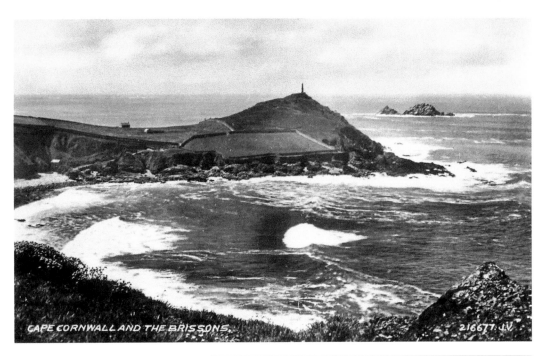

CAPE CORNWALL AND THE BRISSONS. 216677 JV

Rough Seas at Cape Cornwall

Cape Cornwall is a small headland close to the village of St Just. The Sentinel Tower was built in 1875. H. J. Heinz marked their centenary by purchasing the headland and donating it to the National Trust in 1987. The twin rocks seen in the background are known as the Brisons.

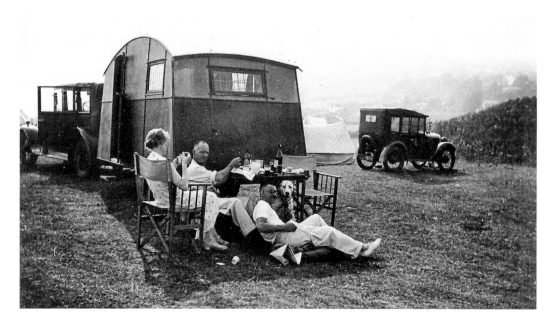

Holidaying in North Cornwall

The older photograph shows the Winton family, again in 1930, holidaying in North Cornwall. It's interesting to see the vintage cars and caravan. Today, this area is the home to many caravan parks which are packed in the summer. The later photograph shows the fields heading towards Trevose Head near to the holiday caravanning sites of Harlyn Sands and Mother Ivey's Bay.

The Eden Project, Bodelva

The Eden Project was constructed in an old china clay pit which was located close to the town of St Blazey. Today, it houses thousands of different plant species. The older photograph shows John Bray Junior on the left with Captain Shelstroom, the operator of a German boat which transported china clay overseas.

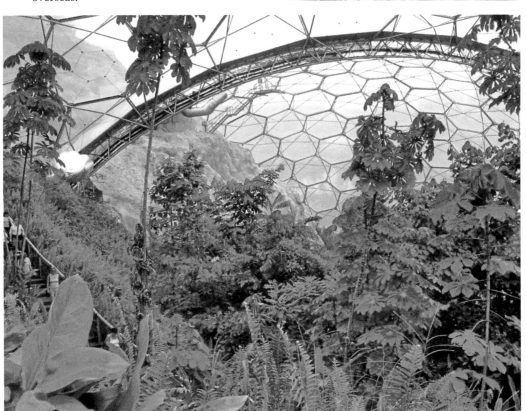

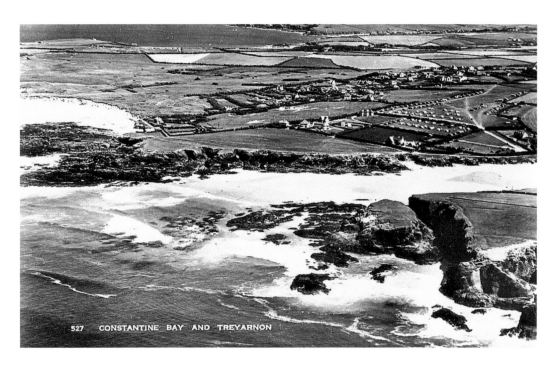

527 CONSTANTINE BAY AND TREYARNON

Constantine Bay with Treyarnon in the Background

The earlier photograph shows the empty fields surrounding Constantine Bay and Treyarnon. Today, many of the fields nearby contain caravan sites together with a popular golf course. The later photograph shows the golden sands of Constantine Bay today.

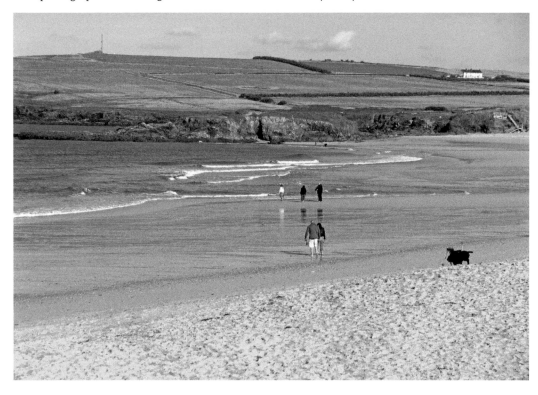

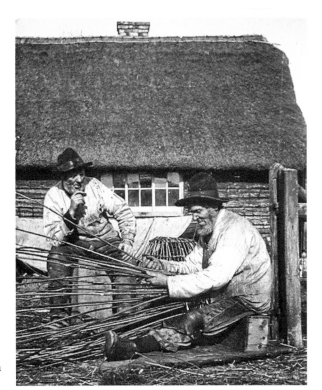

Fishing at Coverack
The older photograph shows two fishermen making their own lobster pots. One of the fishermen is smoking a clay pipe. The later photograph shows the fishing village of Coverack, which lies in the parish of St Keverne. Two fishing boats can be seen tied up in the harbour.

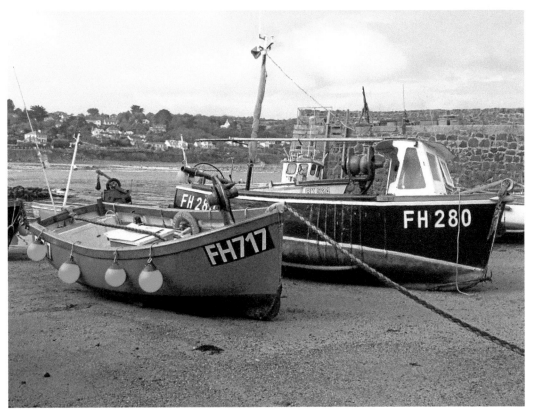

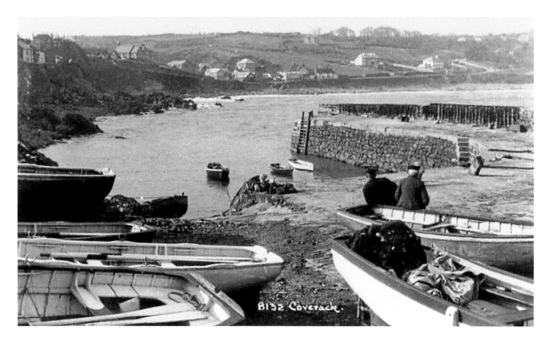

The Harbour at Coverack

Two men look out across the harbour at Coverack towards the sea in the earlier photograph. The later photograph shows that little has changed over the years, although several newer houses can be seen. Although it's a dying trade, there are many more fishing boats in the second photograph.

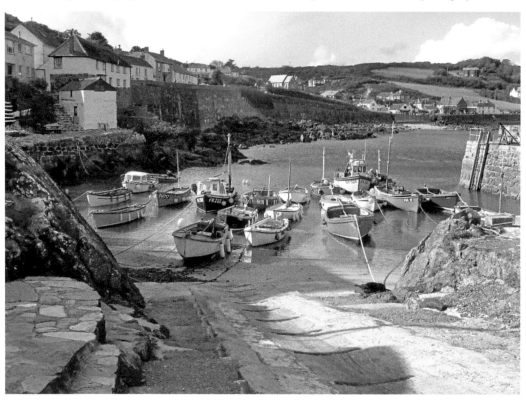

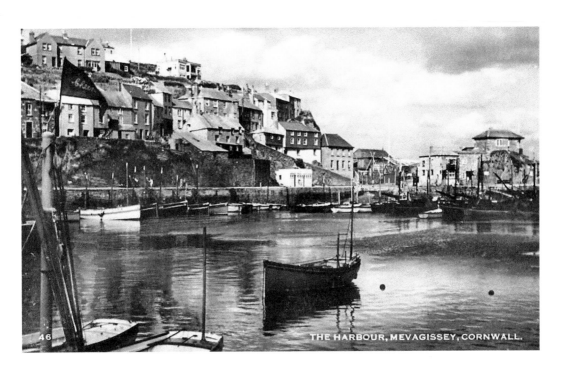

THE HARBOUR, MEVAGISSEY, CORNWALL.

The Harbour at Mevagissey

The older photograph shows the many fishing boats that once moored at Mevagissey. The village was first recorded in 1313, when it was known as Porthilly. Fishing is still carried out in the village but not on the scale that it once was. Like many small Cornish villages, it relies on most of its income today from tourists.

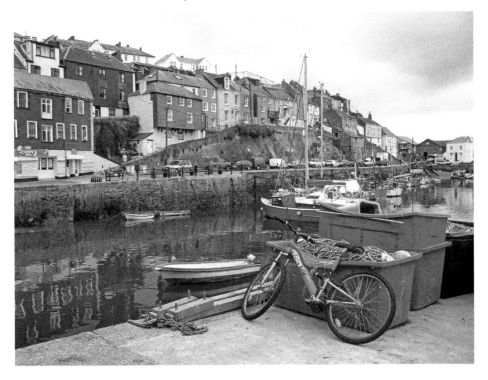

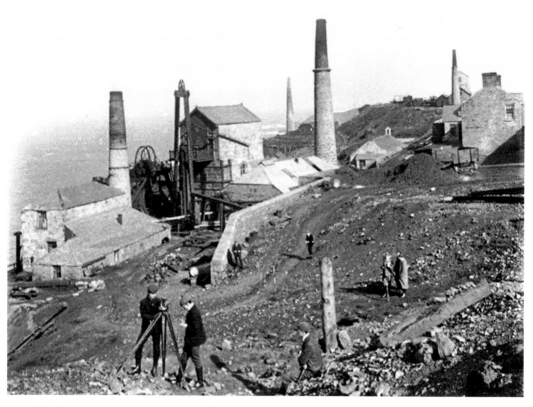

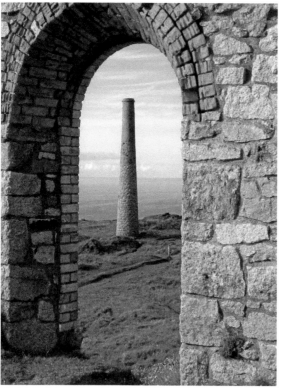

The Levant Mine

The Levant mine opened in 1820 and continued until 1930. As well as producing over 24,000 tons of tin, it also produced 130,000 tons of copper as well as huge quantities of arsenic. The mine stretches from Levant Zawn almost to Geevor.

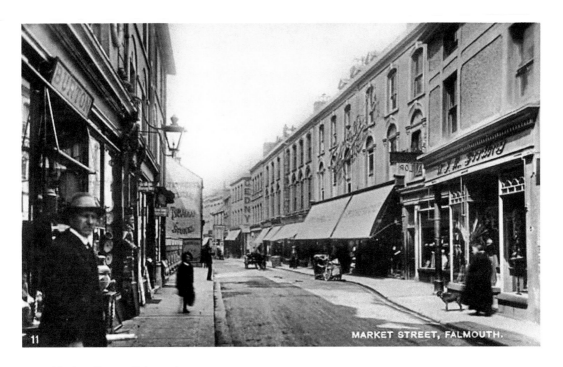

MARKET STREET, FALMOUTH.

Market Street, Falmouth

The older photograph shows the busy Market Street in Falmouth with its many individual and interesting shops. The advert on the shop wall advertises a tobacco store. The newer photograph shows the nearby Arwenack Street and, although the businesses have changed over the years, many of the old shop fronts remain.

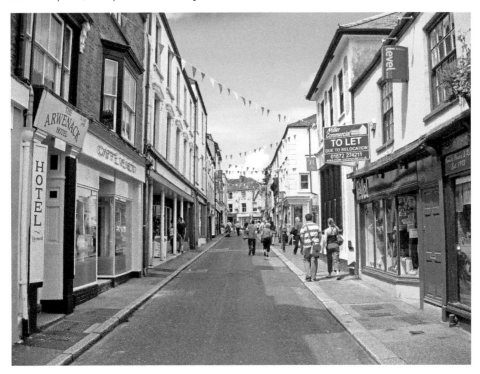

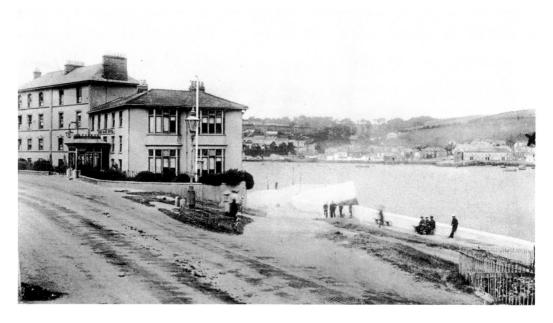

The Harbour at Falmouth

The older photograph shows a quite empty Falmouth when the only transport was by horse. Much has changed over the years and Falmouth is a busy port for luxury yachts with regular sailing events taking place throughout the year. Many round-the-world record-breaking attempts have left from Falmouth, including one by Dame Ellen MacArthur.

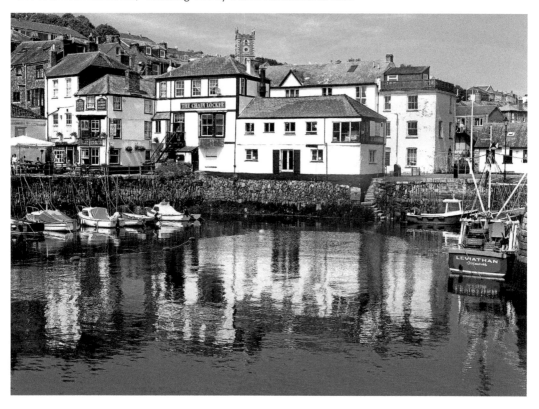

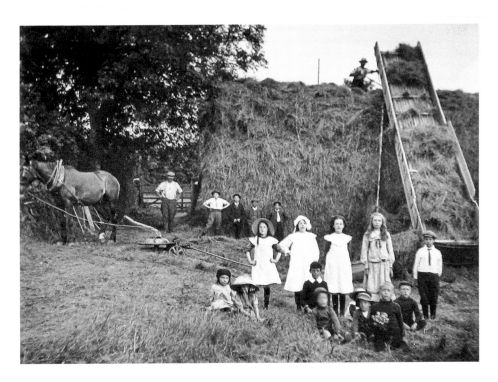

Life on the Farm

Children pose with a farmer and a colleague, who have been busy collecting hay. Today, farming still plays a large part of life in Cornwall. The later photograph shows farmers fields near to Mother Ivey's Bay. Several fields nearby have been taken over by caravan sites but much of the surrounding land is still used as working farms.

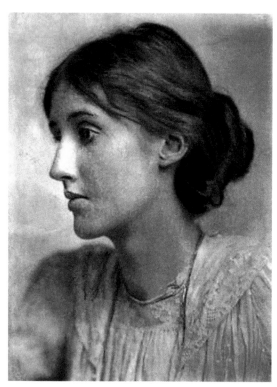

Virginia Woolf and Godrevy Lighthouse

Virginia Woolf's novel *To the Lighthouse* was based in part on her family trips to St Ives during her childhood and their visits to Godrevy Lighthouse. The later photograph shows two artists sketching the lighthouse, which, today, is just as Woolf would have seen it in the late 1800s.

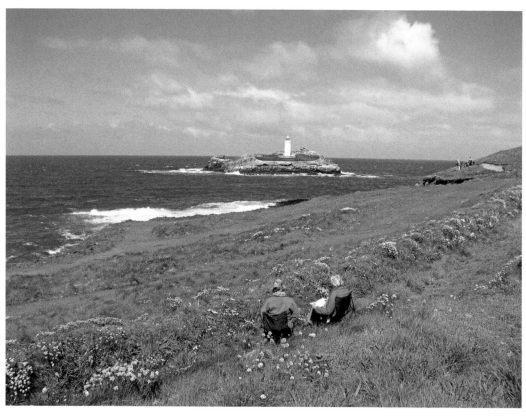

A Lighthouse Keeper, Godrevy

The lighthouse at Godrevy was built in 1859. It was manned until 1939 before becoming automatic. The visitor's book, which contains Virginia Woolf's signature from a visit in 1892, recently went up for sale at Bonham's, where it sold for £10,250. Woolf would have been ten years old at the time of her visit.

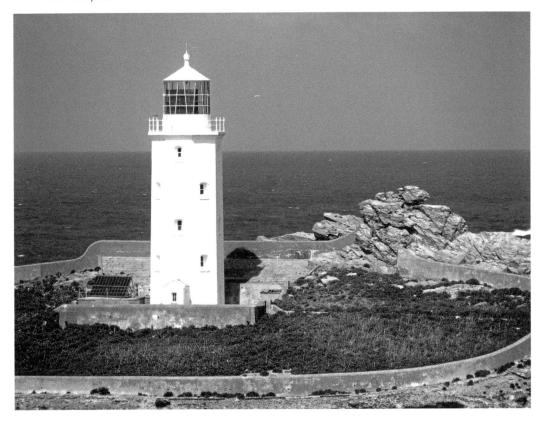

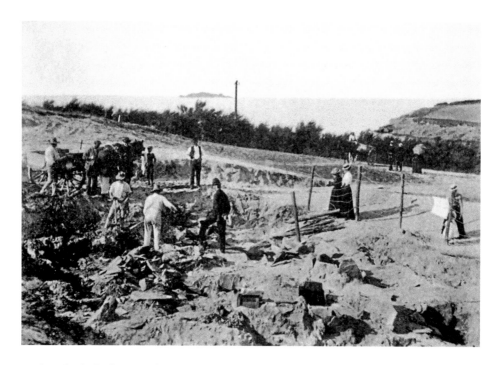

Archaeological Dig at Harlyn Bay

Bronze Age artefacts were discovered at Harlyn Bay in 1865 at Onjohn Cove. These included two gold *lunulae* and a flat axe. The older photograph shows an archaeological dig watched by a policeman and several other people. The later photograph shows Harlyn Bay today, looking towards the lifeboat station.

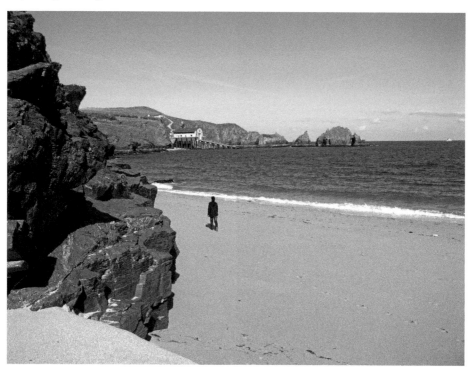

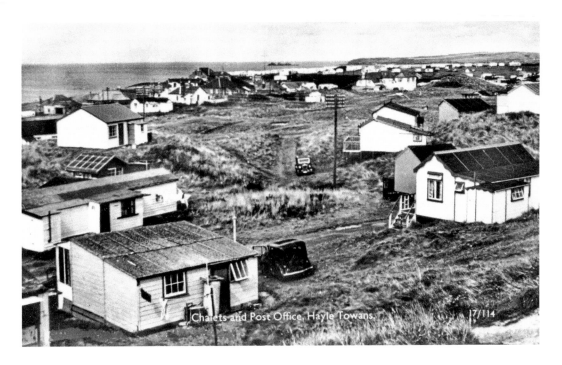

Chalets at Hayle Towans

There have been holiday chalets at Hayle Towans since Victorian times. Some of the original chalets are still there. A few had wheels but these have been buried over the years. Many of the chalets shown in the older photograph are also still there and today the area remains very popular with holidaymakers.

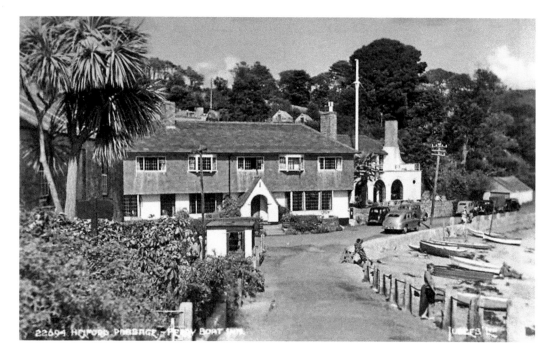

Helford Passage

Helford Passage is situated on the north bank of the Helford River opposite Helford. A small ferry operates between the two villages. The older photograph shows the Ferry Boat Inn with many vintage cars nearby. The inn is still there today and is over 300 years old. Nearby is Frenchman's Creek, which was the inspiration for Daphne Du Maurier's novel of the same name.

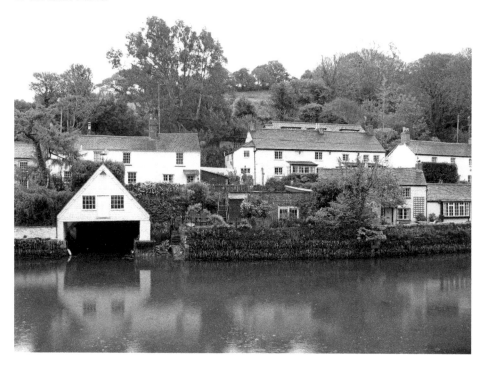

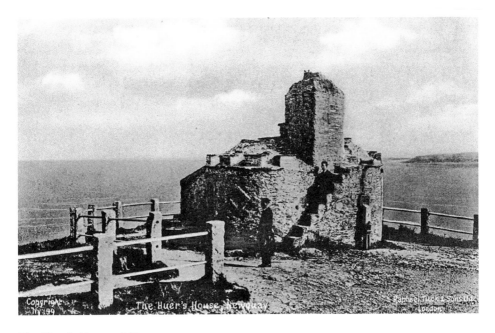

The Huer's House at Newquay

The hut is named after the Huer, who played an important part in the pilchard fishing industry that once thrived in Newquay. The Huer was responsible for pointing out where the shoals of fish were from his vantage point on the hill. The present building is believed to be from the 1800s, although an older building probably stood on the same site many years before.

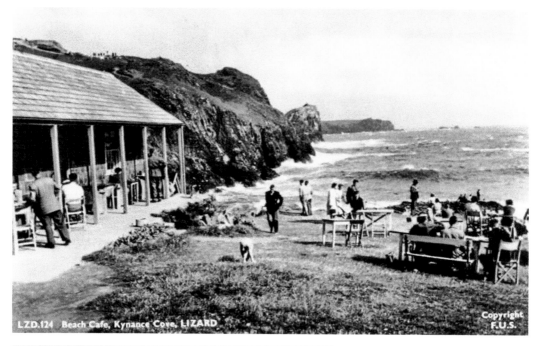

LZD.124 Beach Cafe, Kynance Cove, LIZARD

Copyright
F.U.S.

Kynance Cove by the Lizard
Kynance Cove was very popular with the Victorians and amongst its many visitors at the time was Alfred Lord Tennyson, who was Poet Laureate for much of Queen Victoria's reign. The café at the cove first opened in 1929 and until recently relied on spring water and a generator for its power. When it was purchased by the National Trust in 1999, mains water and electricity were at last supplied.

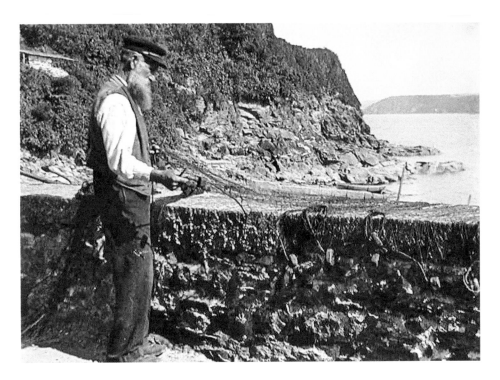

Preparing Fishing Nets at Lamorna Cove

Lamorna Cove became popular with artists from the Newlyn School in the late 1800s and early 1900s. One of them, S. 'Lamorna' Birch, is particularly associated with the area and lived there for a number of years. Other artists drawn to the area included Alfred Munnings, Laura Knight and Harold Knight.

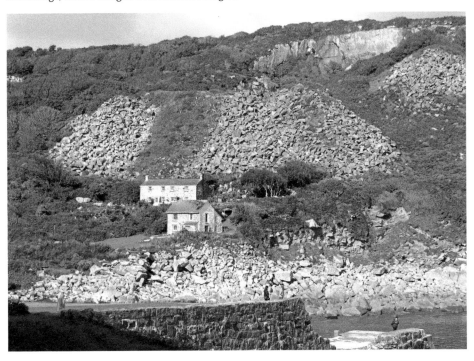

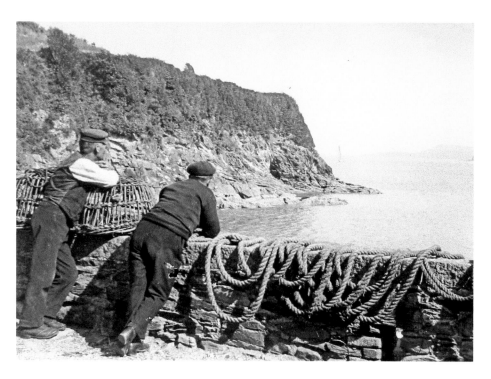

Two Fishermen at Lamorna Cove

Two fisherman look out to sea at Lamorna Cove. One is leaning on a lobster pot. Lamorna Cove has been featured in many books over the years and Sam Peckinpah's movie, *Straw Dogs,* was filmed there in 1971. The Lamorna Pottery was founded by Christopher James Ludlow and Derek Wilshaw in 1947.

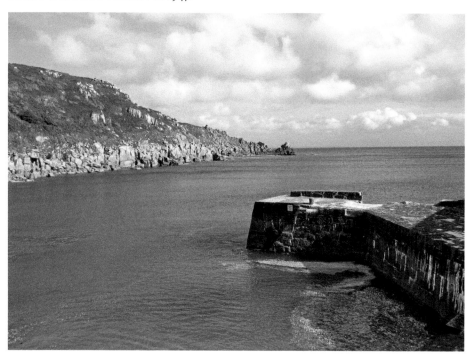

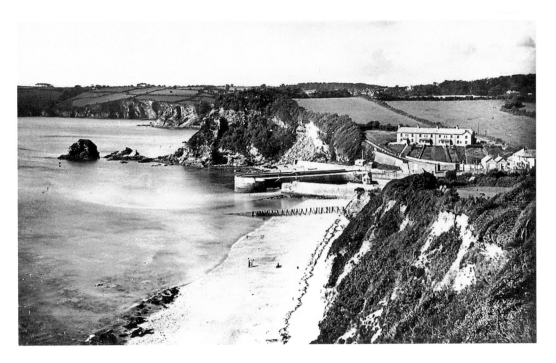

Charlestown

The older photograph shows the beach at Charlestown and the newer photograph shows the nearby harbour. Charlestown was originally part of a small fishing village called West Polmear. The quay was built in the 1700s to load copper from the nearby mines onto barges, but its main function became the transport of china clay.

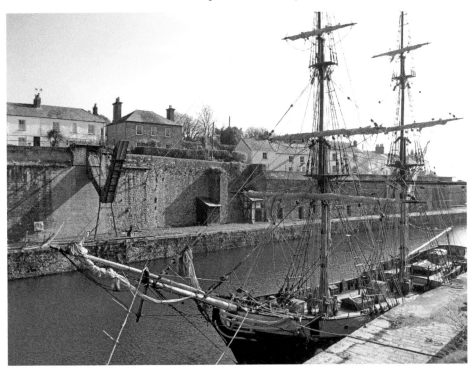

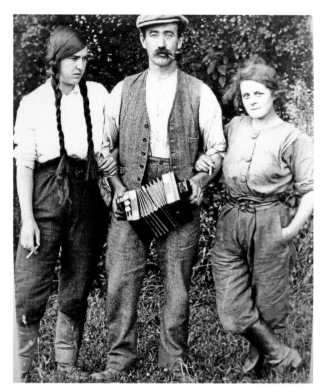

A Farm near Levant

The older photograph shows farm workers taking a break. All are enjoying a cigarette and the man is holding an accordion. The later photograph shows a farm close to the mine at Levant with an inquisitive cow looking over the wall.

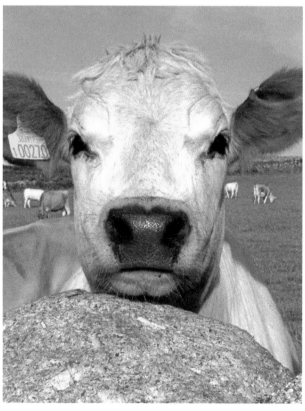

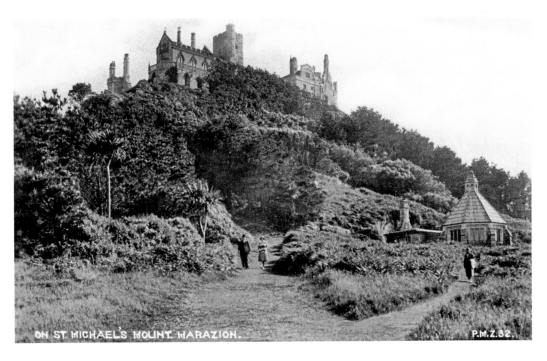

On St Michael's Mount Marazion.

P.M.Z.32.

St Michael's Mount off the Shore of Marazion

The earlier photograph shows visitors to St Michael's Mount in the early 1900s. Today, the castle is the official residence of Lord St Levan. It is owned by the St Aubyn family and the National Trust provides visitor access. The later photograph shows the island from the shores of Marazion.

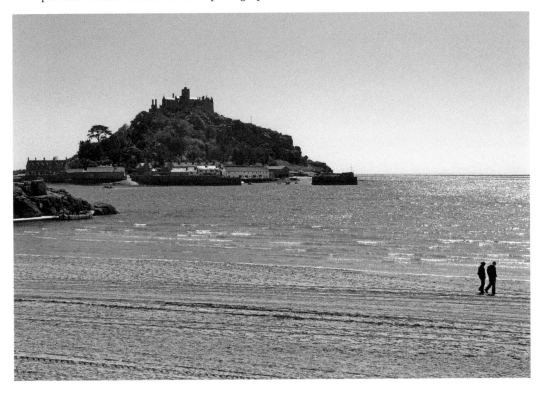

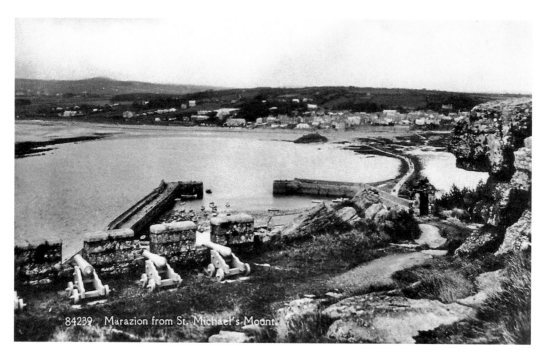

84239 Marazion from St. Michael's Mount.

Looking Back towards Marazion

The older photograph shows the view from St Michael's Mount looking towards the small town of Marazion. Cannons can be seen pointing out towards the sea. The later photograph shows families arriving back at the small jetty at Marazion. When the tide is out, it is possible to walk across to the island.

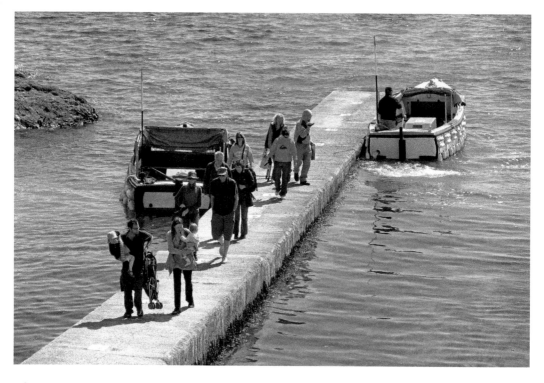

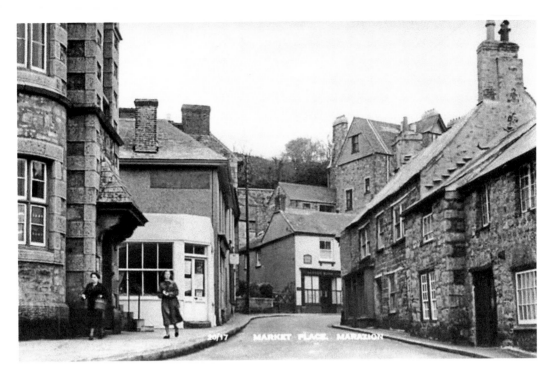

Market Place, Marazion

The earlier photograph shows the heart of Marazion, which still looks much the same today. Marazion was recorded in the Domesday Book of 1088 and is the oldest chartered town in Britain. It's very popular with tourists with its many art and gift shops.

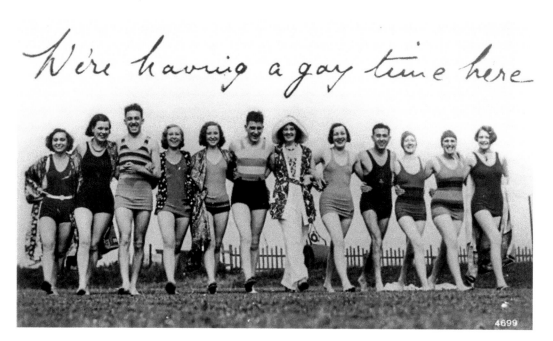

We're having a gay time here

Fun by the Sea

The earlier photograph shows the swimming costumes that would have once been worn by bathers visiting the Cornish seaside. Not only have the fashions changed but the language too. The later photograph shows two surfers, a very popular pastime on today's beaches.

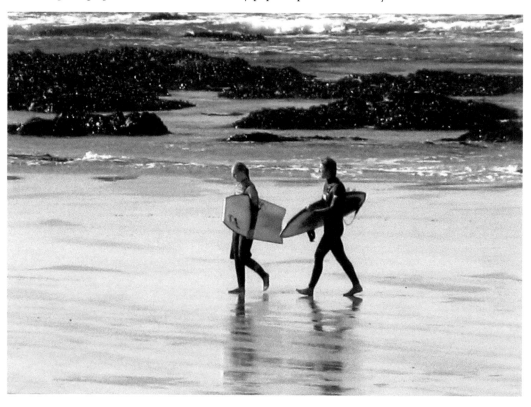

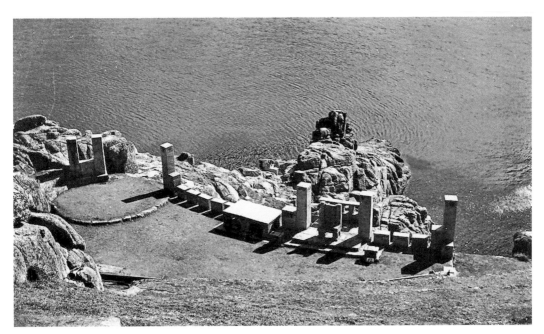

The Minack Theatre

The Minack Theatre was built by Rowena Cade in the early 1930s and she continued to add to it throughout her life. With its magnificent backdrop, it's a very atmospheric place to watch productions. The first performance there was *The Tempest* in 1932 and it was performed again in 2007 to mark the theatre's 75th anniversary.

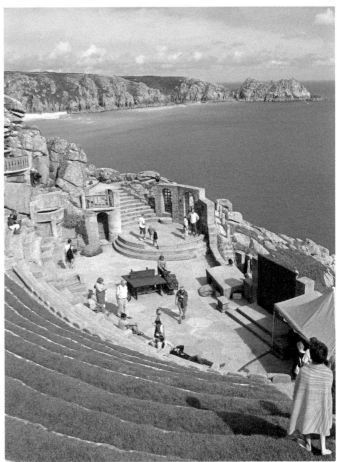

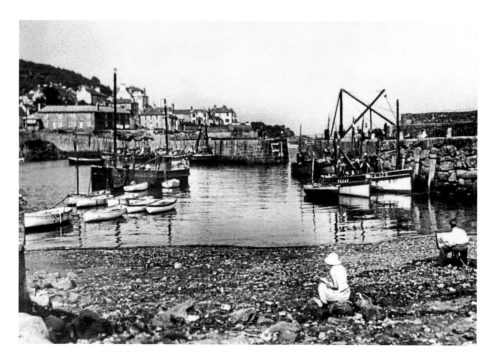

Artists at Mousehole Harbour

The earlier photograph shows artists sketching the scene at Mousehole Harbour. Mousehole was destroyed in a raid in 1595 by the Spaniard, Carlos de Amesquita. The only surviving building from that time is the Keigwin Arms and there is a plaque outside which reads, 'Squire Jenkyn Keigwin was killed here on 23rd July 1595 defending this house against the Spaniards.'

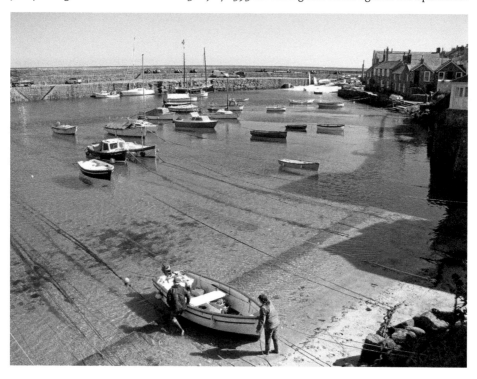

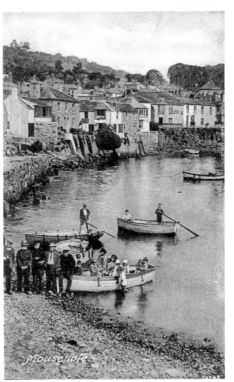

Boat Trips at Mousehole

The older photograph shows a boat trip at Mousehole with many children preparing to row around the harbour. Nothing much appears to have changed over the years although the village is now geared more towards tourism and there are many holiday lets there.

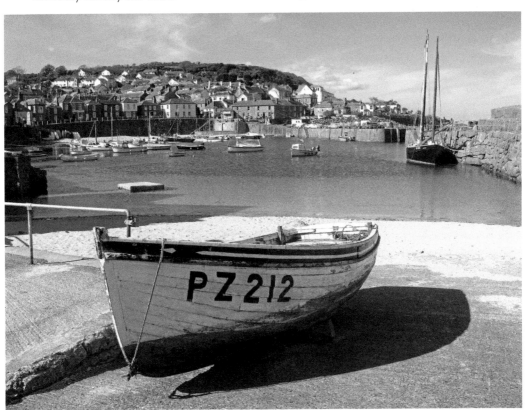

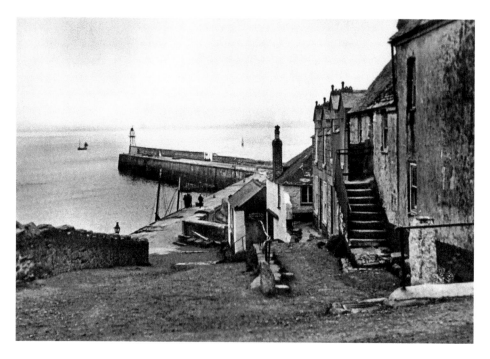

The Fishing Village at Newlyn

As well as being a fishing village, Newlyn is known for the school of artists that were based in the area between 1880 and the early part of the twentieth century. Artists were said to be attracted by the light, the cheap living and the availability of models. Scenes of the lives of fishermen and their families at work appear in many paintings.

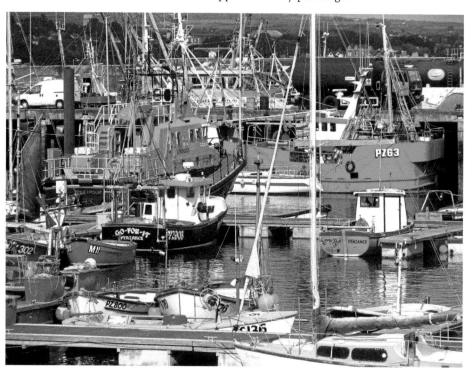

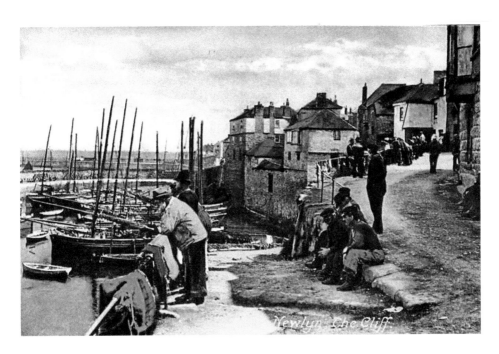

Fisherman by the Harbour at Newlyn

The older photograph shows fishermen by the harbour at Newlyn. Until the 1960s, it was the major catcher of pilchards. The trade of catching pilchards still goes on today, but not on such a great scale. Newlyn is also the home to artists and art galleries and a present day Newlyn School of Art was established in 2011.

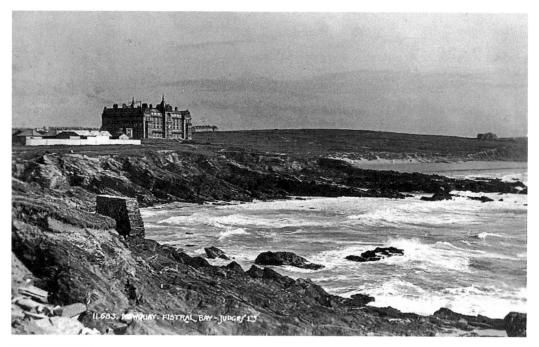

Fistral Bay, Newquay
Today, Fistral Bay is popular with surfers and is the venue for many major international surf competitions. The British Surfing Association is based there. The building in both photographs is the Headland Hotel, which was the location for Roald Dahl's movie, *The Witches*.

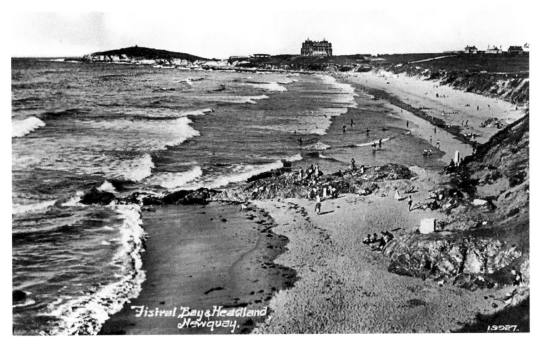

Fistral Bay & Headland Newquay.

19927.

Holidaymakers at Fistral Bay
In the older photograph, holidaymakers enjoy the sands at Newquay. Newquay is also the venue for the annual 'Run to the Sun' event where people come from all over the country with their old VW Beetles and Camper Vans to meet up. The event attracts 100,000 visitors every year.

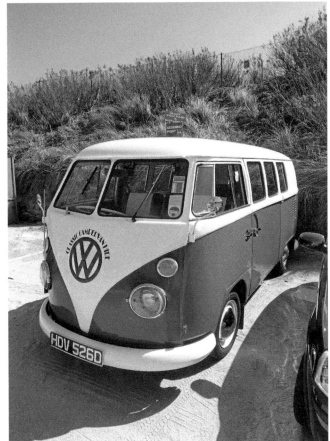

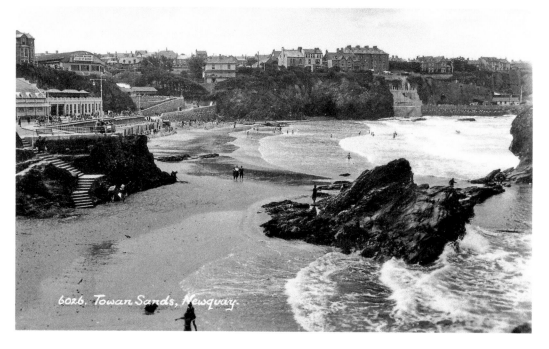

Towan Sands, Newquay

The older photograph shows Towan Sands on a colder day and much of the beach is empty. The later photograph shows the beach from the other direction on a warmer summer's day. An ice cream van is parked on the right waiting for customers. In the background is Towan Island with its famous suspension bridge.

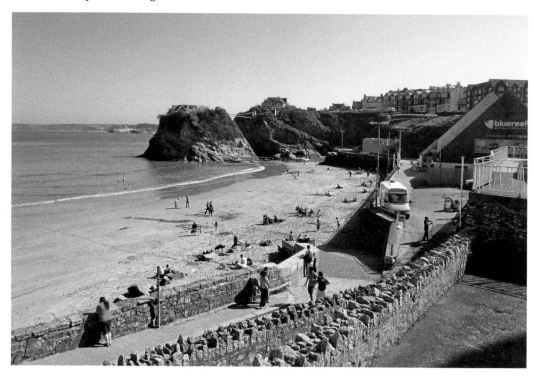

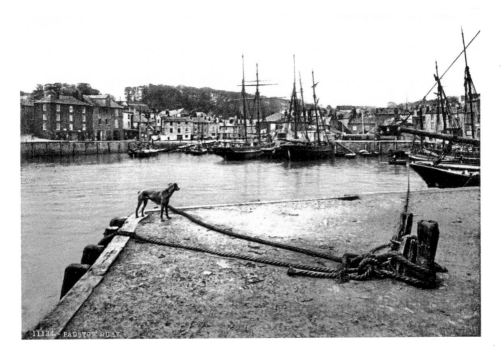

The Quay at Padstow

A lone dog can be seen on the quay at Padstow in the older photograph. There are many older ships in the harbour. Today, Padstow is a holiday destination with many boat and fishing trips. Rick Stein has four popular restaurants there which has led to the village being nicknamed 'Padstein'.

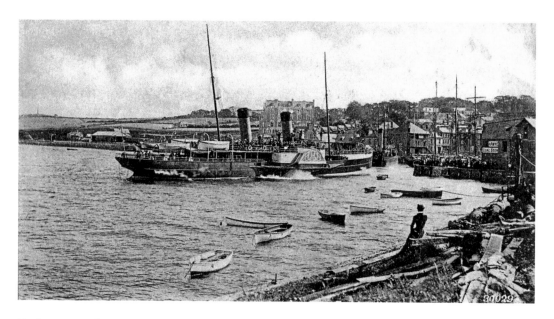

Harbour at Padstow

In the earlier photograph, a paddle steamer laden with passengers approaches the harbour at Padstow. A huge crowd has gathered on the quay to welcome it in. On the right is 'Hawke's Coal Stop'. Today, such boats are now long gone with only smaller pleasure boats leaving the harbour.

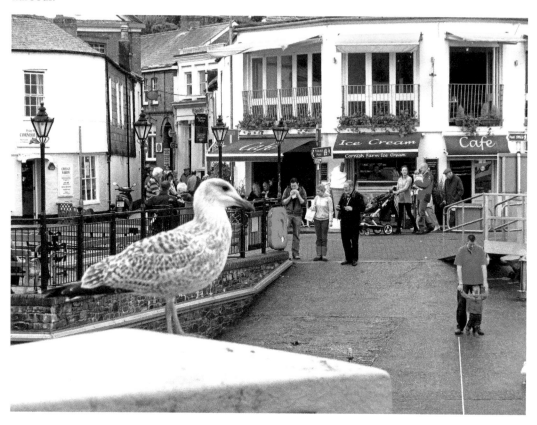

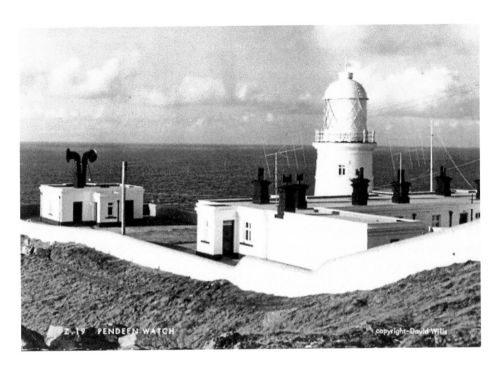

Pendeen Lighthouse

Pendeen Lighthouse was designed by Sir Thomas Matthews. It was supplied with a five-wick Argand oil lamp in 1900, which was replaced with an electric lamp in 1926. The lighthouse became automated in 1995. Today, the cottages nearby, which once housed the lighthouse keepers, are now let as holiday cottages.

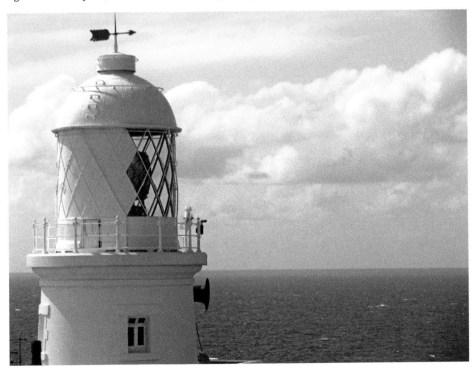

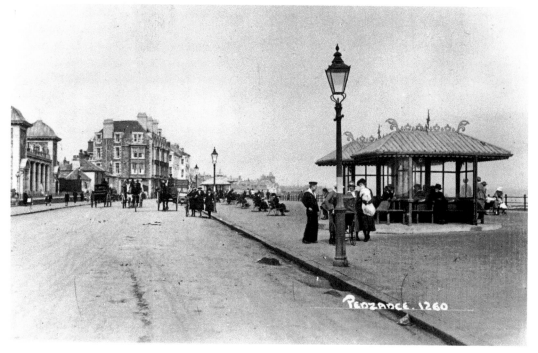

Penzance. 1260

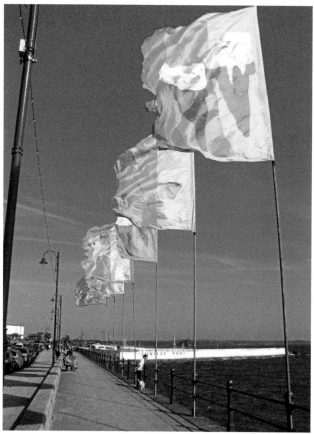

The Promenade at Penzance
A sailor talks to three women,
near to the shelter on the right,
in the older photograph. All
vehicles are horse-drawn and
their droppings can be seen
all over the road. The later
photograph shows the area
today with many colourful
flags along the promenade. The
Jubilee Pool can be seen in the
background. It was designed by
Captain F. Latham, the Borough
Engineer, in the early 1930s.

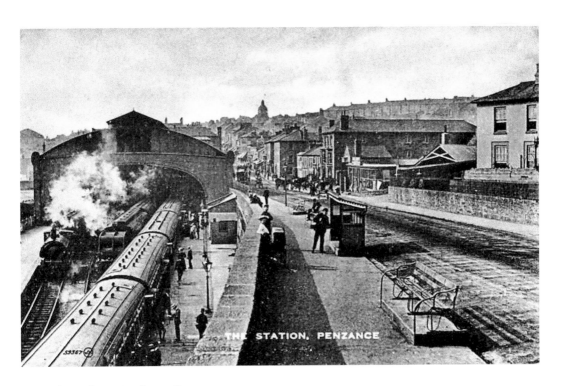

The Railway Station at Penzance

The station was opened on 11 March 1852 and the present building was erected in 1879. It proved very popular with holidaymakers visiting the resort in the early 1900s. The road on the right in the older photograph is very quiet but today, it is very busy with a constant stream of traffic.

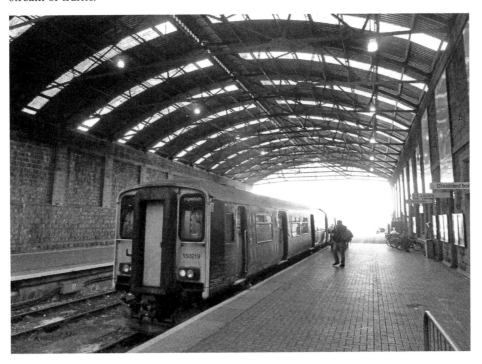

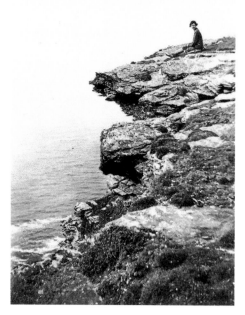

Tintagel

The older photograph shows Lucy Winton at Tintagel in 1930. From this same rock, Robert Taylor threw Excalibur into the sea in the movie *Knights of the Round Table* in 1953. Many locals appeared as extras in the film. The later photograph shows the nearby busy beach. Legends link King Arthur with the ruins of an old castle found there.

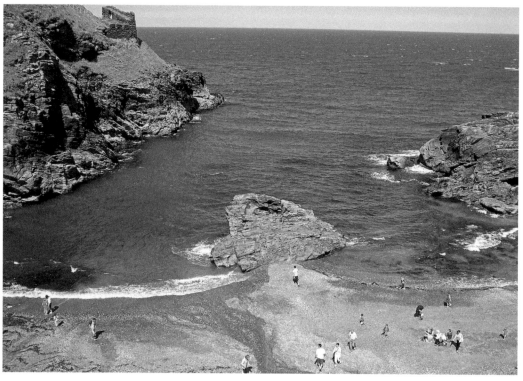

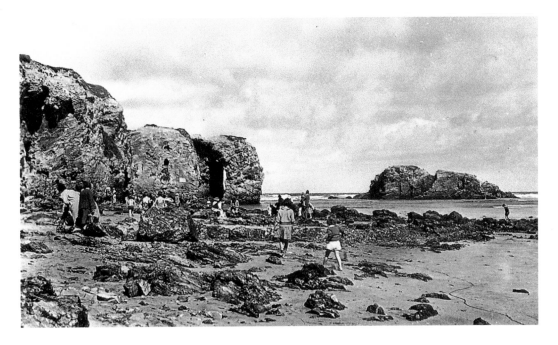

Children Playing at Perranporth

The older photograph shows children playing by Chapel Rock. St Piran, the patron saint of Cornwall, was said to have landed here and he built an oratory which is still preserved in the sand dunes. He is credited with being the first person to discover tin when a black stone in his fireplace got so hot that liquid leaked out. Because of this, he later also became the Patron Saint of Tinners.

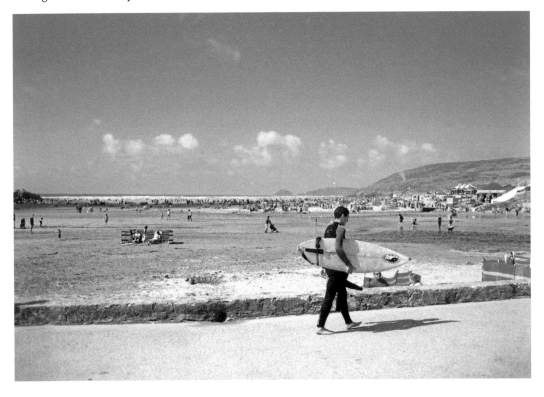

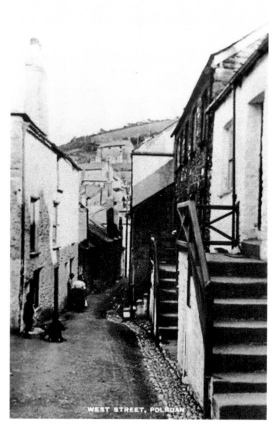

West Street, Polruan

Polruan is directly opposite Fowey. A small ferry runs between the two. Its industries include fishing, boatbuilding and agriculture. It is bounded by water on three sides. To the north is Penpoll Creek with the River Fowey on its west and the sea to the south.

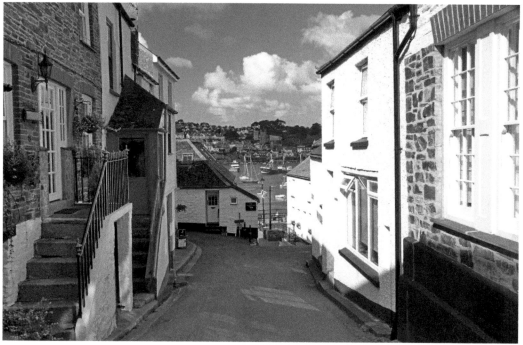

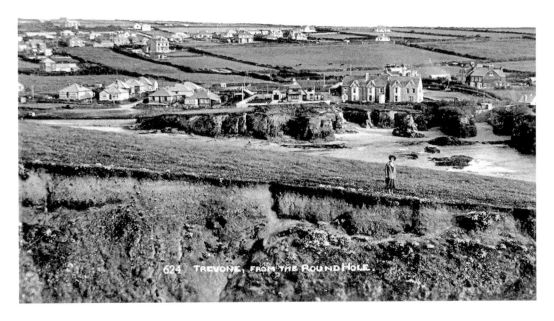

The Round Hole, Trevone

The older photograph shows a woman standing beside the massive crater in the hillside at Trevone. It was formed when a sea cave collapsed many years ago. There is another one further around the coast. The later photograph shows the busy beach at Trevone on a summer's day.

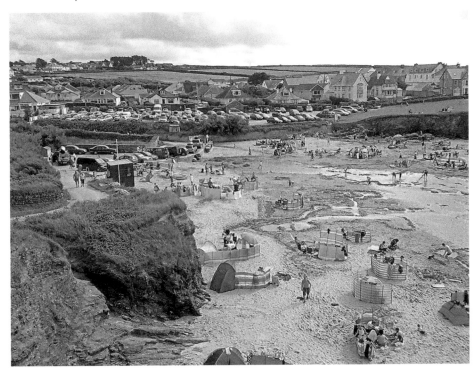

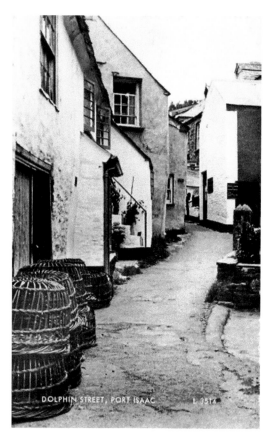

Dolphin Street, Port Isaac

The earlier photograph shows Dolphin Street in Port Isaac. On the left of the photograph can be seen many lobster pots. The later photograph shows the narrow street heading down towards the harbour. The village is well-known today for being the setting for the television show, *Doc Martin*.

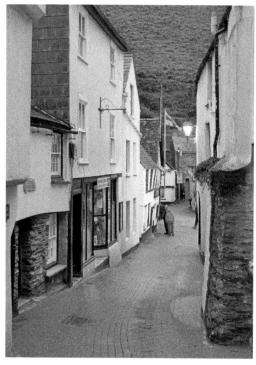

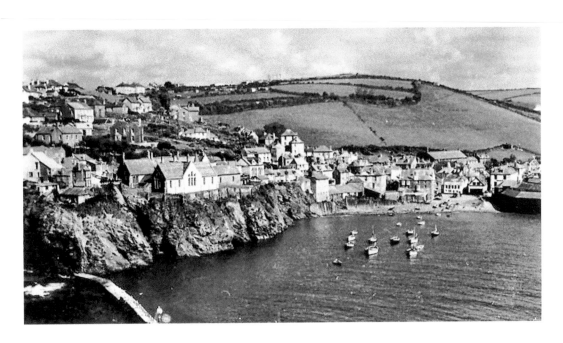

The Village of Port Isaac

The older photograph shows Port Isaac from the sea. Several fishing boats can be seen in the quay. The village was a busy port from medieval times until the mid-nineteenth century when coal, stone, timber and pottery were loaded and unloaded there. The later photograph shows the view from the harbour looking through an old rusty anchor.

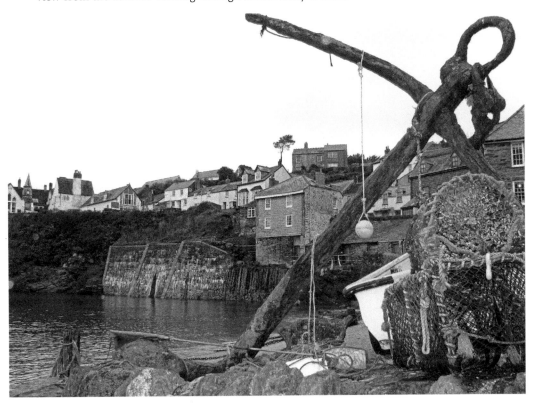

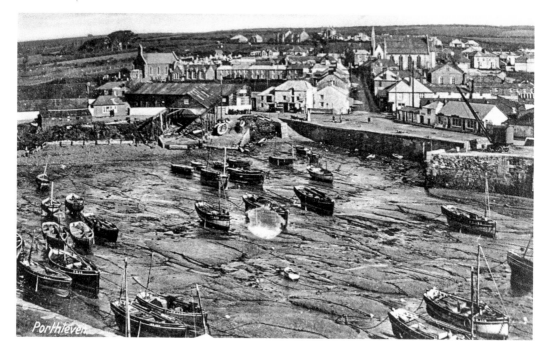

Many Boats at Porthleven

Many fishing boats can be seen in the harbour at Porthleven in the older photograph. The town is the most southerly port in Great Britain. It is popular with tourists and surfers in the summer months. Its most recognisable building is the Bickford-Smith Institute, which stands next to the pier.

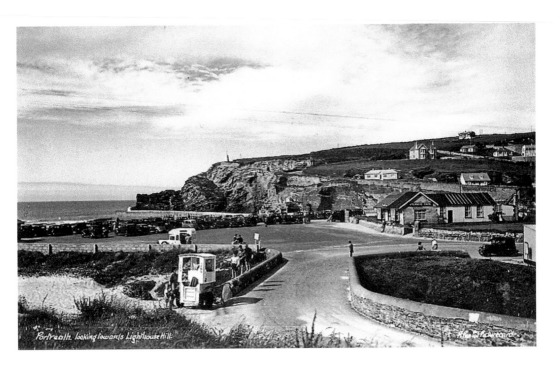

Looking towards Lighthouse Hill from Portreath

A small ice-cream cart can be seen on the left of the older photograph. The Atlantic Café can be seen in the background. The name Portreath means 'sandy cove' and it was first recorded in 1485. Pilchard fishing became one of its main trades in the 1700s. The later photograph shows the beach today.

The Road to Praa Sands

Praa Sands name in Cornish translates to 'Witch's Cove' and there is supposedly a haunted castle nearby. Regular ghost-hunting activities take place at Pengersick Castle, which is said to be one of the most haunted places in Britain. The village originally served the mining community but today is more popular as a holiday resort.

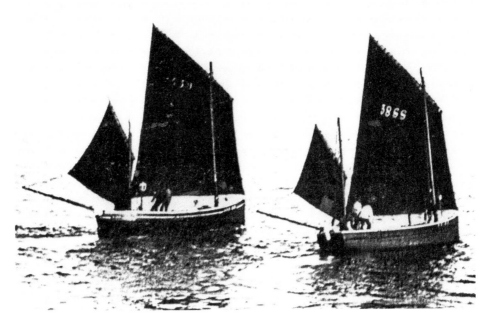

Luggers at St Ives

The older photograph shows a very early photograph of a pair of luggers in St Ives harbour. Luggers were used by fishermen in their search for pilchards and herrings. The boats are still to be found in the harbour at St Ives and two can be seen passing behind the seagull in the later photograph.

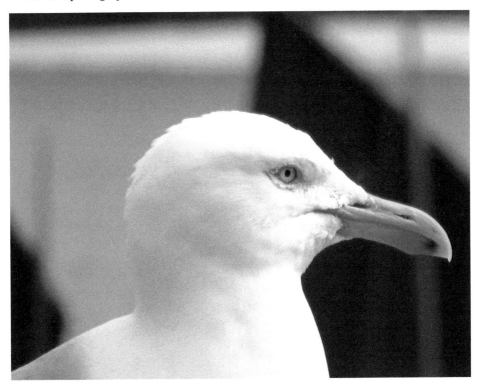

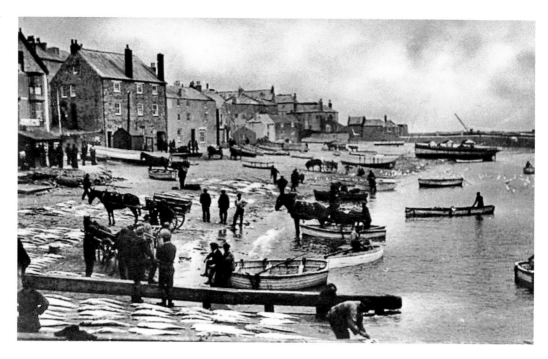

The Fish Market at St Ives

Horses and carts wait on the shores of St Ives to take away the day's catch in the earlier photograph. In the background can be seen Smeaton's Pier. The pier, complete with lighthouse, appears in the later photograph showing the view of the beach looking across the harbour.

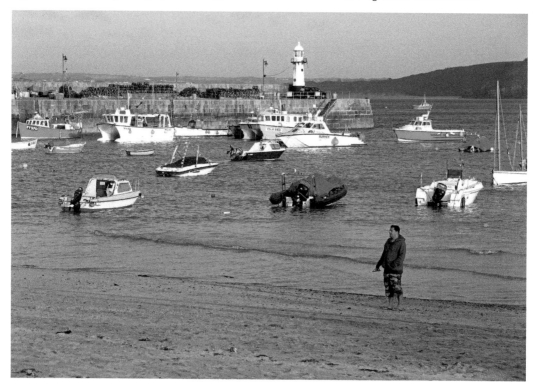

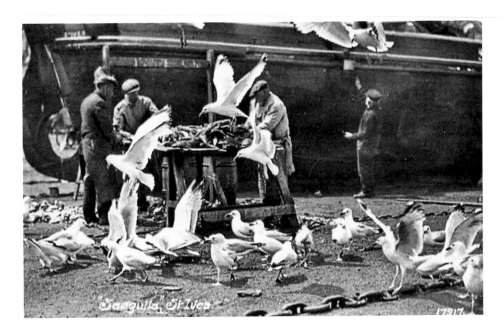

Seagulls at St Ives

Many seagulls gather in the earlier photograph as fisherman gut their recently caught fish. Seagulls are, perhaps, more of a problem today but for a different reason. Many holidaymakers soon find that the chips or pasty they've just bought is quickly snatched and taken away by a rogue bird.

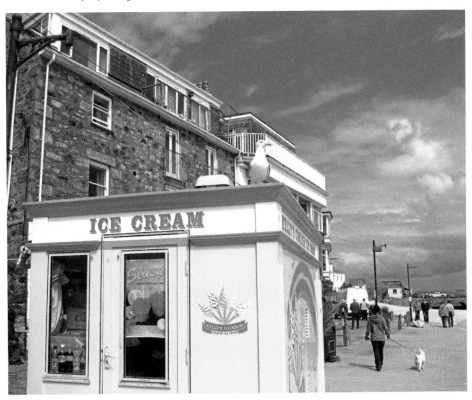

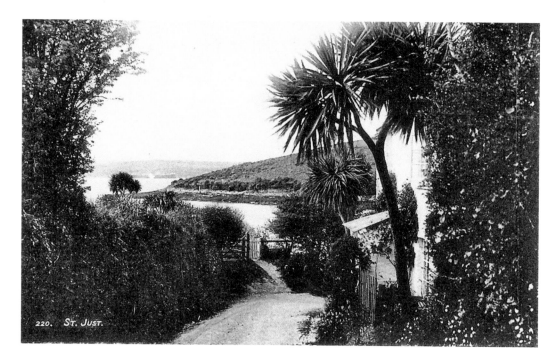

St Just

The earlier photograph shows the scenic path leading down towards the beach at St Just. The area was once one of the most important mining districts in Cornwall. The later photograph shows Market Square at St Just with its many shops including a pub, the King's Arms, an art gallery and a fishmonger's.

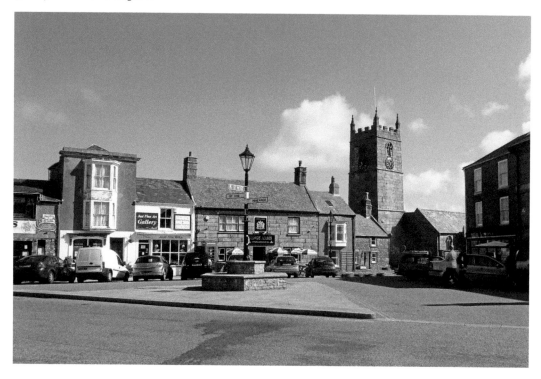

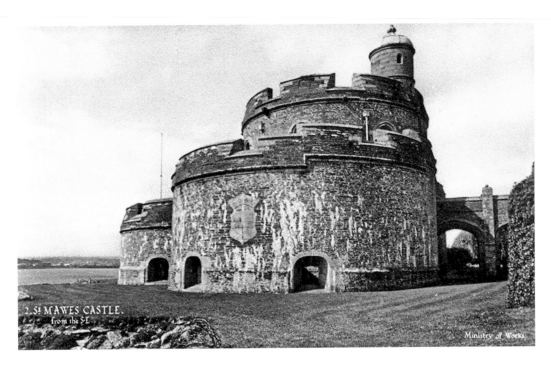

St Mawes Castle

St Mawes Castle was built by Henry VIII as a coastal artillery fortress in the 1500s when the country feared attacks from France and Spain. The later photograph shows the path, with its beautiful views, leading away from the castle heading towards the shoreline.

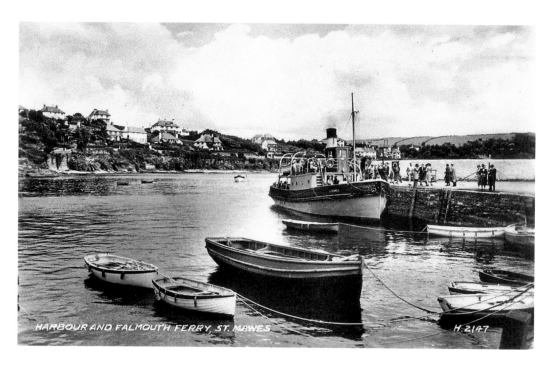

The Falmouth Ferry at St Mawes

The older photograph shows the Falmouth Ferry waiting for passengers at the harbour at St Mawes. The ferry still runs, although it's a different vessel, and provides a service to over 100,000 visitors each year. The later photograph shows the town and harbour from a nearby headland.

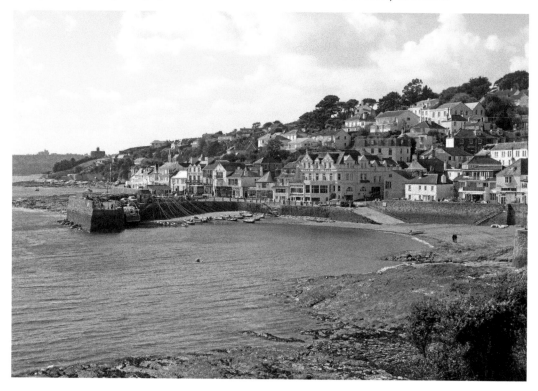

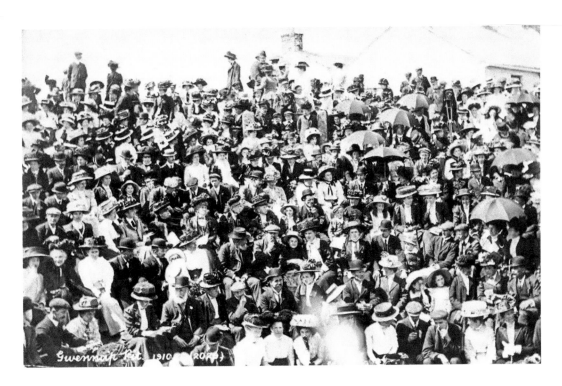

Gwennap

The earlier photograph shows a Methodist meeting at Gwennap Pit in 1910. The mine had previously collapsed, causing a depression in the land, which was then used as a preaching pit by John Wesley in the 1700s. It was said that 1,500 people could easily be seated on the twelve rings that surround the main preaching area.

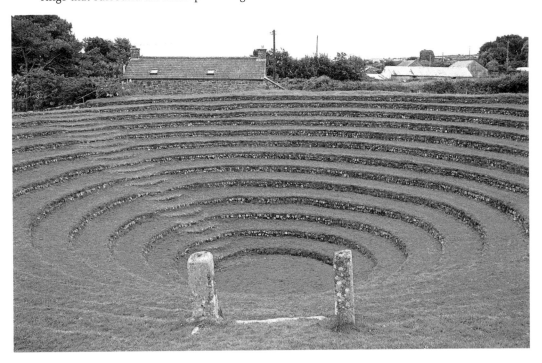

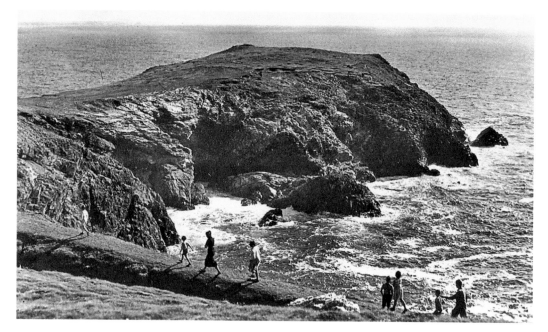

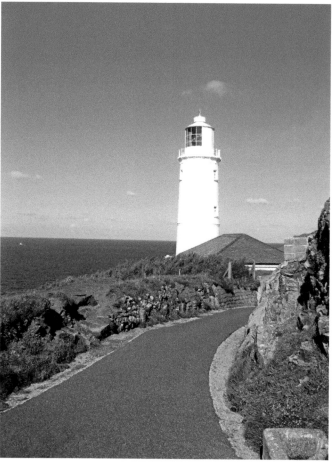

Walkers at Trevose Head
A group of walkers can
be seen by the cliffs at
Trevose Head in the older
photograph. Little has
changed in this scene
today. The path leads in
the other direction towards
Trevose Head Lighthouse,
which was established
in 1847. The lighthouse
became automated in 1995.

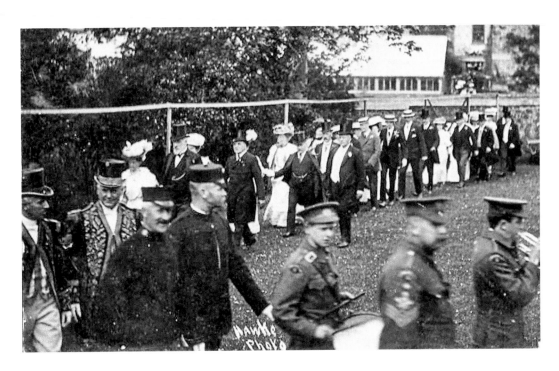

Flora Day, Helston

The earlier photograph shows a parade for Flora Day in Helston in about 1915. The event takes place every year during May and includes many activities including the Furry Dance. The later photograph shows members of a local band taking part in a modern Flora Day.

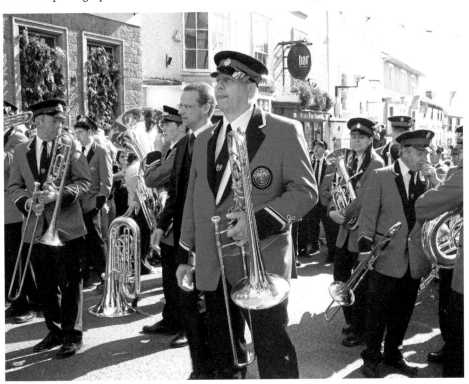

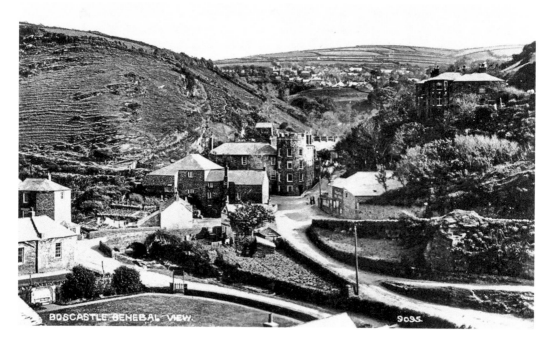

BOSCASTLE GENERAL VIEW. 9095.

Boscastle

The older photograph shows a view looking across the village of Boscastle. On 16 August 2004, a flash flood caused extensive damage to the village. As well as the bridge, fifty cars and the visitor centre were washed away. The Royal Air Force Sea King rescue helicopters saved ninety-one people and the only injury reported was a broken thumb.

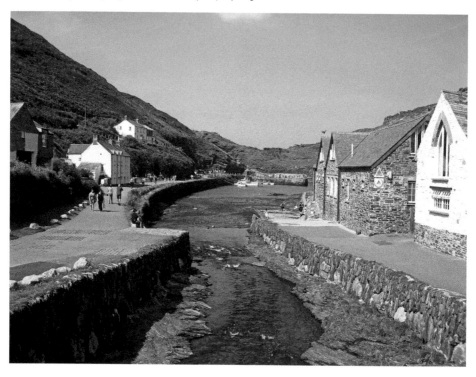

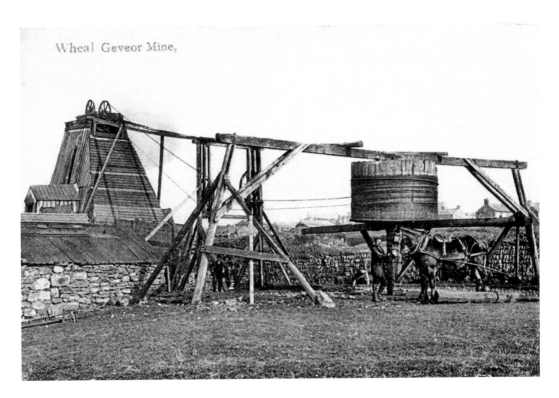

Wheal Geevor Mine

The tin mine at Geevor was operational between 1911 and 1990. In this time, it produced approximately 50,000 tons of black tin. Tin and copper had been mined at Geevor from the late 1700s. Today, the mine and its workings form part of a museum and heritage centre.

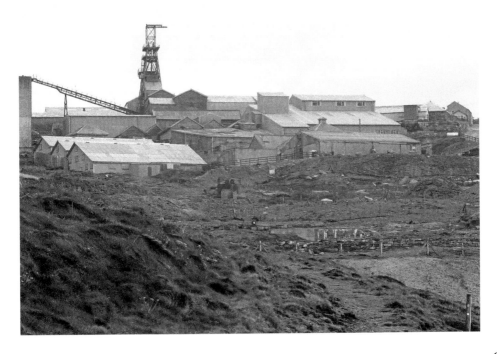

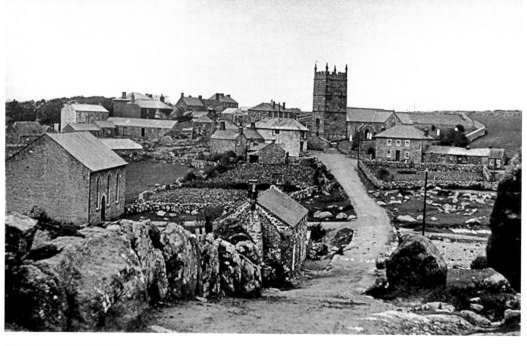

The Small Village of Zennor

The earlier photograph shows the approach to Zennor. The rock on the right is where John Nelson, one of Wesley's preachers, was said to have given a sermon in 1743. The village is also famous for its tale of a mermaid who fell in love with a villager, Matthew Trewhella, and took him back into the sea with her.

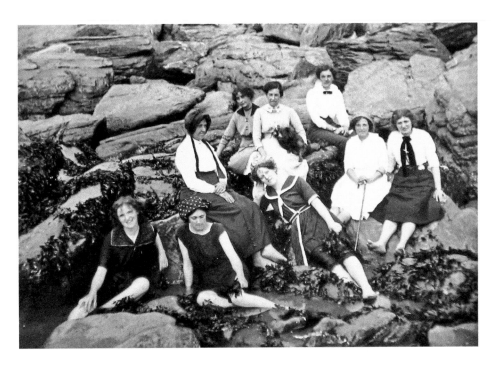

Sennen Cove

The older photograph shows a group of bathers relaxing on rocks near to the sea. Sennen relies on its living from tourism and the many surfers that visit the area. It also has a small fishing fleet. The later photograph shows the view from a window of a harbourside shop looking across Sennen Cove.

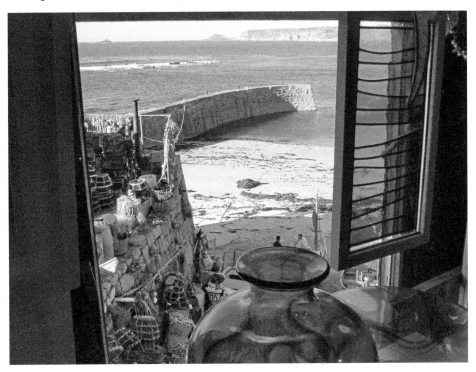

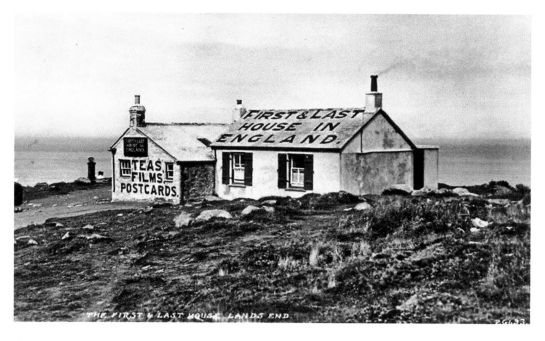

The First and Last House at Land's End

The older photograph shows the first and last house in England at Land's End which is selling teas, films and postcards. The area has been more developed in recent years and now features many attractions, a shopping village and eateries. The later photograph shows the signpost where every tourist has their photograph taken.

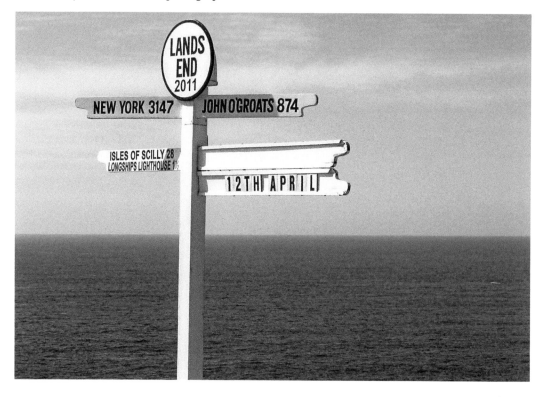